THE WAY OF FAILURE

WINNING THROUGH LOSING

MARIANA CAPLAN

HOHM PRESS

PRESCOTT, ARIZONA

COVER DESIGN:

Kim Johansen, San Francisco, California

LAYOUT AND DESIGN:

Celina Taganas-Duffy, Tustin, California
www.taglineinc.com

Epigraph on p. vii from: *The Subject Tonight Is Love, 60 Wild and Sweet
Poems of Hafiz*, trans. by Daniel Ladinsky, (No. Myrtle Beach, So. Carolina:
Pumpkin House Press, 1996). Used with permission.

LIBRARY OF CONGRESS CATALOGING IN PUBLICATION DATA:

Caplan, Mariana, 1969-
 The way of failure : winning through losing / Mariana Caplan.
 p. cm
 Includes bibliographical references
 ISBN 1-890772-10-0
 1. Failure (Psychology)—Religious aspects. 2. Success—Religious aspects.
 3. Spiritual life. I. Title.

BL629.5.F33 C36 2001
158—dc21 00-054213

HOHM PRESS
P.O. Box 2501
Prescott, AZ 86302
800-381-2700
http://www.hohmpress.com

This book was printed in the U.S.A. on acid-free paper using soy ink.

OTHER TITLES BY MARIANA CAPLAN

When Sons and Daughters Choose Alternative Lifestyles

When Holidays are Hell . . .! A Guide to Surviving Family Gatherings

UNTOUCHED: The Need for Genuine Affection in an Impersonal World

Halfway Up the Mountain: The Error of Premature Claims to Enlightenment

For my mother, Mollie Caplan,
who failed me at times,
and at times whom I have failed
but who I hold in my heart of hearts
Eternally.

ABSOLUTELY CLEAR

Don't surrender your loneliness
So quickly.
Let it cut more deep.

Let it ferment and season you
As few human
Or even divine ingredients can.

Something missing in my heart tonight
Has made my eyes so soft,
My voice
So tender,

My need of God
Absolutely
Clear.

—Hafiz

ACKNOWLEDGEMENTS

Were I to acknowledge all the people who have helped me to "fail" in life up until this point, and whose help has thus been priceless in allowing me to "successfully" complete this project, the book would have to be double in length simply to make space for proper credits. You all know who you are, and I can only hope for your forgiveness and release. I will probably continue to fail you, and will hope still and again for your redemption.

I would like to particularly thank Lee Lozowick, for continually pushing me past my perceived limits, and holding me to my ultimate commitment. May you never cease demanding perfection from me, in spite of inevitable failure, and may you hold me to my vows to serve life fully and without reserve, even when I pretend to never have agreed to such a liberating and graceful task.

I would also like to extend a sincere thank you for the generous and reliable help of Regina Sara Ryan, my editor and dear friend; Thom Shelby, devoted publicist of Hohm Press; and Kim Johansen, graphic designer par excellence.

CONTENTS

INTRODUCTION

THE BOOK YOU ARE about to read is about FAILURE. It is about LOSING. By the time you finish reading this book your vision of failure and loss will hopefully have undergone a radical restructuring, but not before you have reconsidered the most common failures of human life.

You could have chosen to read one of five thousand books about every kind of success, self-improvement, new key to happiness, unprecedented sexual pleasure or radical financial gain. But instead, you chose to read and I chose to write a book on *failure*, and we did so because failure is an unavoidable and even essential aspect of every human life and we know it. We humans live with failure and experience it as often as not. And somewhere within us we intuit the possibility of deeply coming to terms with failure such that it is transformed into a kind of fertilizer for the soul— a soul that thrives on the *reality* of human experience as opposed to an unattainable fantasy.

If we look around, it is obvious that everybody wants to succeed in life. In every corner of the earth, no matter what one's gender, creed, culture or religion, everybody is trying to succeed. Whether we work on Wall Street trying to succeed in earning our first million, or as a laborer in

India trying to make a few rupees to buy some food for our child, or even if we're a panhandler on the streets of Paris trying to beg enough money for a drink, in our own way we are each trying to succeed. We are trying to win. Unconsciously we perceive life as a race to overcome death, and all of our actions—from the most mundane gesture to the largest enterprise—are primarily a function and expression of our will to survive and our fear of dying. We believe that if we don't "win," then we lose; that if we don't get what we imagine we want, in the way we think we want it, then we will have lost—lost the opportunity to be happy, to be free of suffering, to have conquered life and death. It's not that all of these beliefs are conscious, but rather that they comprise the unconscious fabric that serves as the referent for most of our small and large life choices. We don't understand so-called failure and loss for the gifts they really are.

In the time between conceiving the idea for this book and preparing for press, I have lost many things: my partner of several years, my mother who is dying to cancer, my previous home, my sense of security, my vision of what my life was to be, as well as a small mountain of beliefs about who I thought I was. Perhaps more than anything, I lost my conviction that I could control life. I came upon forces that were simply beyond the domain of my well-developed capacity to manipulate life and circumstances. The losses have led me to grief, but the grief has led me to love, and in the love I finally begin to experience a fullness I had only heard about. I wrote *The Way of Failure*, and then I *experienced* this way. For me, to write a whole book about the value of conscious suffering, loss and disappointment, and then assume that the failures in my life were accidental or that I was somehow a victim of circumstances, would be naive. When one has professed to the world the

profound depth of understanding that can arise from loss, she can no longer turn away from or condemn herself for imagined failures that she knows have the capacity to become precious assets.

Actually, so-called "failure" has become my true friend. In fact, I can no longer separate my countless apparent failures from my equally numerous seeming successes, nor can I profess to always know which are which. More often than not, success and failure blur together into a continual flow of changing experience that I can only call "my life." The many failures during these past months have revealed a far more realistic picture of who I am and particularly where my weaknesses and my strengths lie, a revelation that admittedly has not been pleasant much of the time. I have become disillusioned with many things I once believed about myself, but this stripping away has also left me with clarity. The process of being humbled by my failures has left me raw and open, and thus measurably more available to life and to the ones I love. As someone who has hidden behind a stream of successes, my failure has made me more real and more connected, and has finally demanded that I not insist upon my separation from people. These are only a few fruits of the early harvest, fruits that are available to anybody who walks the Way of Failure.

Thus, in opening to failure on its own terms, a new kind of success becomes available. There is a quality of self-worth that lies beneath all gains and losses. There is a place to dwell within ourselves that does not depend upon the flow of continually changing circumstances. When our ground is taken away (as it often is when we experience failure) and we find we are still standing, then we begin to discover something we might call groundlessness. When, through loss after loss, we finally become available to life as

it is, the measure of our success changes. When we start to undermine the very notion of failure itself, particularly the morass of conclusions we draw about ourselves based on what we have misunderstood in the first place, then we do change—although perhaps imperceptibly at first. We learn that authentic success is gauged through the quality of our humanness and our beingness, and not the ups and downs that are a constant marker of the inner and outer events of our lives.

What is the true nature of this failure we so fear? Is it something actual or is it simply the difference between our expectations of life and of ourselves, and what actually happens? Is it certain that we can fail at all? And if we can fail, is our failure the result of "doing it wrong," or is it that we are disappointed by idealized and unrealistic expectations that we alone have placed on ourselves and on life?

Failure is a great paradox. On one hand we fail all the time. We could have done better and we didn't. We missed the mark. We betrayed ourselves or somebody else. We made a mess of things. On the other hand, when we learn to use failure as a gateway to self-understanding, and especially when we come to uproot the very notion of failure itself, we discover we cannot fail. Both are true: we fail and we cannot fail. *The Way of Failure* is about all of this and every large and small failure in between.

The Way of Failure is a realistic exploration of the profoundly ordinary and simultaneously extraordinary reality of attempting to live a life of integrity and satisfaction amidst an extremely challenging and often frustrating circumstance called life. It is a passionate call to fulfill our lives as they are now, instead of using spiritual ideals as yet another form of anesthesia to numb our feelings of disappointment and disillusionment. In fact, *The Way of Failure*

represents the possibility of success in the most unlikely and unexpected of places—in that dark, dismal and most avoided dungeon of loss itself. This is the very place where we don't want to go but the place that is waiting for us no matter where we hide.

Failure cannot be tricked. We cannot fake our way into being open to failure and then expect all gains to be ours. We will be disappointed. The Way of Failure has no short-cuts. Crossing the finish line feels great, but the training is tough. Failure does not feel like success. It often feels like total, abject, and often even inconsolable grief. Yet, since we are to fail no matter what we do, and an intentional engagement with failure yields far greater gains than an attempted forfeit, why not risk running toward it? What do we have to lose—really?

The culmination of my personal initiation into the Way of Failure took place only a short time ago. When my alarm clock sounded I was drowned in sleep such that I had totally lost my reference in terms of space and circumstance. I mechanically turned off the alarm but had no idea where I was or what was going on in my life. Vague images floated through my mind: somebody was ill, some really good and some really awful things had happened, I might still be overseas, or in California, or perhaps I had even gone somewhere else. Yet, instead of scurrying around my mind to locate myself as I would have done in the past, my first conscious thought was this: "Whatever it is, it's okay and I'm okay." If circumstances were favorable or not, I could tolerate it. If my current situation was secure or insecure, I could handle it. If disappointment or grief was present, I would move through it. If joy was going on, fine. Success and failure were both okay since I was essentially all right. Imagined failure had lost its grips. I got up and went to my

new university teaching job, happy that fifteen years of spiritual life had finally begun to pay off.

When failure and loss become stepping stones on the path of deepening our experience of life in all of its guts and glory, then we have entered the Way of Failure. When failure is respected, and even appreciated, it responds with great generosity, delighted that we have not turned away from the substance of our own lives, and happy to do whatever it can to forge the deepening of our experience.

Onward and downward we go.

CHAPTER 1

INVESTING IN LOSS

TO INVEST IN LOSS sounds like a very strange thing. To intentionally place valuable inner and outer resources on the table of failure with a promise of losing them seems all but absurd. But it's not. When we appreciate the value of loss—that it can provide us with something that nothing else can—then we find ourselves doing strange things that yield equally surprising outcomes.

The crucial point to understand is that loss and failure are already ours. We all are experiencing them a lot of the time and will continue to do so in greater and lesser degrees throughout our lifetimes. The only difference is whether we "play" our losses or forfeit the game. If we forfeit, we have already lost; if we play, something else may happen.

Paradoxically, we stand to "gain" far more through our investment in loss than through our investments in winning. We stand to gain by the conscious placing of our intention upon the experience of the many losses, failures, lies and expectations that comprise the dream world of ego, thus allowing the falseness in our egoic lives to fall away, and reality itself to be revealed. Only our failure to understand the role of loss in our lives keeps us insistent upon trying to win!

When loss and disappointment are understood in terms of our ordinary definitions of failure—which essentially means that we have failed ourselves (self-blame) or that somebody or something else has failed us (projected-blame)—then we can make little use of them. Such definitions get us caught up in outdated psychological ideas and patterns of failure. We endure these losses, distracting ourselves, trying to compensate by making something good happen or at least by eating a lot of chocolate or drinking a lot of wine, and then we move on. But when we learn to embrace the inevitable failure and loss as the substance of our lives, then so-called failure and so-called loss are no longer what they were. They are instead secret doors that open to direct passageways leading to the potential fulfillment of our own humanity. Suddenly we are willing to invest any and all resources to pass through these doorways.

Isn't it strange that whenever something doesn't go the way we think it should that we call it *failure*? When the universe doesn't comply to *my* wishes, *my* perfectionism, *my* preferences, I assume that I have failed. For example, when I cannot do something as well as I imagine I should, I have failed. When I do not get the job I wanted, then I have failed. When I am unable to feel loving and happy every day, I have failed. When I burn my food I have failed. When my kid takes drugs I have failed. When my husband leaves me I have failed, and when my dog dies I have failed. When we examine the range of experience that human beings unconsciously lump into the category "failure"—by whatever name we call it—it can be hard to do *anything* right.

Without reviewing the whole content of introductory psychology and spirituality here, it is important to understand the origins of our desire to win, as well as the intensity of our resistance to loss. In so doing, we can appreciate the depth of what failure symbolizes in us, and also the internal strength that can be gained by forming a new relationship to these primary forces in our psyche.

The human infant—born essentially whole with no perceived separation from God—is immediately plummeted into a world of duality, difference and separation. Oftentimes even before birth, a notion of the ego, or of a separate self, begins to form within the infant that will continue throughout his or her lifetime. Even the rare few individuals who never experience any greater betrayal than that of the inevitable fall from union with God will still unconsciously suffer the loss of remembrance of that oneness, and a longing for its return.

In addition to the inescapable perceived loss of union with God, what happens to the vast majority of infants and young children in the West is that at some point in their early lives they will have at least one experience, and often many, of profound psychological betrayal. This may come through outright sexual, physical or verbal abuse, but is as likely to result from something subtle and unintended, such as the failure of the mother to respond immediately when the infant wakes up hungry in the middle of the night, or from unknowingly shaming the child for urinating in bed, or from any other number of unconscious and understandably human behaviors that even the best of parents enact. In spite of the most loving intentions, the young child is all but destined to experience a sense of primal loss that the parent cannot even

imagine because he or she has been accustomed to living in such a state of loss for most of his or her life.

What ordinarily happens is that this initial loss will be unconsciously internalized within the child, then forgotten. He or she will then spend untold years engaging in an infinite number of distractions in order to avoid those initial feelings of loss, since for the child these feelings were literally unbearable. Addictions, unhealthy relationships, all forms of neurosis, and an essential closing down and cowering to life are only a few of the symptoms that human beings express in their attempt to assuage feelings of betrayal and loss. In fact, a large part, if not most, of our ordinary lives is an expression of this loss.

As an example of our avoidance of loss, when we walk down the street and see a homeless person, we are likely to look away in fear. We might think we are afraid of being accosted or harassed, but more often we are afraid of the uncomfortable feelings that may arise within us upon considering his condition. Or, when we are criticized or asked to examine an oversight within ourselves and we instead open the refrigerator or light a cigarette, we are saying "no" to failure and loss. When a friend confides to us her sorrows and we are filled with the impulse to try to make her feel better instead of being willing to touch her sadness with her, again we are turning away from loss. Of course we only turn away from somebody else's loss because when we experience their loss we are experiencing our own. Failure and loss are common to all of us; thus we cannot share the experience of loss with someone else if we have not felt our own.

When we begin to grasp the nature of failure and loss— the magnitude of the deep fear and imagined betrayal we are all running from although we do not even know it—we begin

to understand more easily and with more compassion *why* the checkout clerk at the drugstore looks so forlorn or the bank teller so painfully mechanical in his behavior to us, or even why we ourselves mistreat our own children. We believe that the unfelt pain of an earlier reality will be *unbearable* if felt, and we must deny it at all costs, including the cost of hurting ourselves or the ones we love most.

Understandably, the child turned away from loss, but the maturing adult who wants to *live* cannot afford to turn away from it indefinitely. At some point we must re-turn ourselves in the direction of failure and loss in order to embrace the greater fullness that life offers.

If we look at life, we see that it begins with birth, which we associate with winning, success and happiness; and ends with death, which we associate with loss, failure and sorrow. And yet, from a different perspective, we all know that birth and death cannot be separated from one another because what life *is* is a series of cycles of birth and death. Even the day must die for the night to be born, or our own son must die to his teenage-hood in order to be born a man. For human beings to be in alignment with a greater intelligence of the universe—an intelligence that produces a tremendous sense of belonging to the world—they must necessarily respect and accept the laws of that intelligence, which include loss and gain, birth and death. If we are only willing to embrace joy and success, and will tolerate our failures and losses only with terror, apprehension and shame, we will live partial lives, and our ideals of spiritual growth and transformation will remain forever distant and unfulfilled.

Obviously re-turning to loss is not as simple as saying, "All right. I'm going to feel all the pain and sorrow of my life, and everybody else's life while I'm at it, so that I can embrace failure and lead a full life." Oftentimes our entire persona is structured precisely in order to avoid these feelings (the comedian type, the invulnerable hard-body type, and even the victim, depressive type of personality are all examples of this). This means that *who we are*—not ultimately, but nonetheless all of who we know ourselves to be—is an avoidance of that loss.

The process of re-turning in the direction of loss begins with a simple willingness to acknowledge that we are the keepers of a dark and hidden treasure we call loss. The next step is to create an *intention* to begin to seek that hidden resource within. Daring to enter into the domain of failure simply involves the voluntary gesture to take a short break from our obsession with success and gain, while we look in the direction of loss in order to see if anything of value awaits us there.

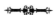

Conscious suffering is the process by which we learn to transform our imagined failures into fruits of the soul. The term itself is a paradox, for anything we apply consciousness to changes the composition of the thing itself, and thus conscious suffering is something altogether distinct from our common experience of suffering. Ordinarily we consider suffering as undesirable. We avoid it at all cost, and when we encounter it we tighten up and turn away from it. Suffering is the enemy, unfavorable circumstances the perpetrator, and we the victims of the universe. In conscious suffering, however, we appreciate the capacity of suffering

to forge deep tracks of wisdom and compassion within us. Not only do we no longer turn away from suffering, but we consciously engage circumstances that will involve discomfort or loss when we sense that there is gain to be had. Conscious suffering really means that we turn toward our suffering instead of running from it. We shine the light of our awareness and inner strength upon it, and in so doing it changes.

There is a process of alchemy—or transformation— that takes place in the human body when we accept loss. The *athanor* was the furnace used by the alchemists of old in which they turned lead into gold. They took something people did not see as valuable and turned it into riches. In this same way, the process of the acceptance of loss itself— as opposed to the experience of any one specific loss—turns what we imagined to be a frightening or "bad" event or situation into something precious, though perhaps invisible. Our loss is alchemetized, so to speak, into an understanding of human nature, into compassion, into clarity. What were once rigid defenses become soft and malleable, what we hid from becomes an open secret, and our vulnerability becomes our strength.

"Good situation, bad situation; bad situation, good situation," says the contemporary Zen master Seung Sahn. What he means is that when everything is going well— when we are "winning"—we often become absorbed in our success to the degree that we block out the rest of reality as well as anyone or anything that threatens to stand in the way of our enjoyment. Our "good" situation may be great for ego, but is not always the optimal situation for overall spiritual growth; whereas so-called "bad" situations in life are often the most fertile opportunities for deepening our

understanding of life, as well as our capacity to feel compassion for others.

When the great Tibetan master Chögyam Trungpa Rinpoche was asked what he did when he found himself in a situation of great stress, chaos, pain and discomfort—what the practitioners of his tradition call a "hell realm"—he responded, "I try to stay there as long as I can." How many people can say that they are even willing to go into a hell realm without kicking and screaming all the way down, much less take up residence there voluntarily?! Yet Trungpa Rinpoche would stay there as long as he could because cultivating the capacity to navigate through the "hell realms" of loss, sorrow, terror and confusion—those realms of our unconscious that are the most difficult and unpleasant to endure—is one of the greatest skills we can discover. Most of us will at some point experience great pain and illness, and all will experience death, and our chances of being able to make use of those passages will depend precisely upon whether or not we have allowed ourselves to be students of failure and loss.

Buddhist scholar Reginald Ray suggested that in any given experience of ecstasy, abundance or joy, many Buddhist practitioners will consciously look for the place of suffering within the experience, because that place represents reality. Again, it is not that we *want* to suffer, or want to feel pain and loss, but instead that we seek the treasures that the acceptance of these domains will provide us.

To further clarify this point, a distinction must be made between neurotic suffering and objective suffering. Neurotic suffering is what we often think of as suffering, but it is actually an experience of our emotions that is exaggerated and dramatized in order to cover over deeper feelings of actual loss. For example, if a woman's partner breaks up

with her and she starts drinking, sleeps around a bit, spends hours lamenting to friends about how miserable her life is and how awful he was for leaving her, in one sense she is suffering, but it is neurotic (not *bad*) suffering and is also an avoidance of the experience of loss. Yet, if through our neurotic suffering we allow ourselves to deepen into the very real pain of loss and sorrow, and to experience that feeling wholly, then our experience is objective. Neurotic suffering includes our thoughts and judgments and fears about our suffering, as well as the suffering itself, whereas objective suffering is simply that: suffering from loss with no ideas, cover-ups or excuses for it.

When we say we want to invest in loss it does not mean we start to make a stage production over every emotional drama or difficult experience that arises within our lives. Instead, investing in loss is a willingness to turn toward the difficult things that arise in our lives instead of attempting to manipulate and control every millimeter of our experience and every person in our lives in order to avoid the discomforts that are inherent in, and an essential aspect of, life itself. The whole point of walking the Way of Failure is to appreciate that failure and loss are as essential to life as winning and gaining are, and that by consistently trying to suppress the reality of failure we are all but destroying our planet, ourselves, and our relationships with those who surround us.

The following chapters take us on a walk down the avenue of failure. Again, perhaps nobody in their right mind would choose such an apparently unappealing setting for an evening on the town, but it really depends upon what you're shopping for. If you want a superficial dose of conventional happiness, Saks Fifth Avenue is just around the corner, or easily accessible on the Internet.

CHAPTER 2

THE FAILURE OF (ORDINARY) LOVE

LOVE: THE GREAT TASK of humanity. Every human being is literally dying for love. We are born from love, spend our lives trying to "get" (or really discover) the love that is always around us but so difficult to perceive, and then we die into love. The reality of the universe is that we are all totally and unconditionally loved, but due to cultural, environmental and psychological conditions, we often fail to realize that truth and instead continue to strive for love as if it wasn't already totally available. We all want love so badly that the most minute details of our lives are driven by it. We do the things we imagine will get us love, and even become the people who we imagine will attract it. We are often disappointed. Such is the case with "love" as we ordinarily understand it.

In order to discuss the failure of ordinary love, we must make a distinction between two different expressions of love. Most commonly we consider love as the love between people. We consider ourselves successful in love if we have a wholly fulfilling relationship with our husband/wife/partner, with our children, and with other dear friends and close ones. We usually consider ourselves a fail-

ure or partial failure in love according to our degree of expressed weakness in each of these areas.

The second kind of love has to do with our essential capacity to love. Period. Not to love or be loved by *someone*, but simply to love. As I will continue to explain throughout this book, our success or failure in the first kind of love is one-hundred-percent dependent upon the ability to love itself. *love w/o an object ?*

To begin with, let's examine the first kind of love, which we could call "romantic" or "emotional" love. This type of love is such a profoundly difficult task for human beings to master that very few, when pressed to be honest, will say with confidence that they have loved as fully as they are capable of. From one perspective, this admission of our failure to love is substantiated: we generally don't love well. The roots of our inability to love, as we have already mentioned and will reiterate in the chapters that follow, are commonly based in childhood wounding. But whatever their source, we as human beings tend to be weak in this arena.

Most of us were not loved well and did not learn to love others. We rarely saw models of strong, loving relationships within couples. It occurred to me one day that I was twenty-one years old before I witnessed a deeply fulfilling love relationship between a husband and wife. I never even knew that I had not had solid models of loving relationship until I was in its presence for the first time and realized how surprising it was. Further investigation into other people's experience revealed very similar reports.

Most of us fail at ordinary love again and again throughout our lives. Whether or not we are married for years on end is surely not the marker to our success in love. Nor can we say we love well simply because we have

a dependent relationship full of clingy affection, or because we played at being compliant or subservient with our partner, or have put up a good front of compatibility for others. Nothing but our own conscience can measure whether or not we have succeeded or failed in our love, but our own honest assessment in this regard is to our great advantage. Only through the admission of our own lack of love do we have any semblance of a chance of discovering a love that is real.

Last year I was at a seminar listening to a devastating account of a middle-aged man who was at his wit's end after enduring years of his wife's struggle between her love for him and her love for another man. The guy was shattered, and there was nothing he could do about it. From any standard of success in ordinary love, and certainly from the perspective of his own aching heart, the man was losing. He was losing the woman he loved, he was losing his pride, he was losing his self-worth, he was losing an investment of precious years, and in some way he was dying within. Yet, to look at this man, his heart cracked wide open and bleeding profusely, no one could deny the love that was there. Nobody would ever wish such a loss even on an enemy, but his so-called failure had broken down the protective walls of his heart that had previously been so tightly structured as to be impenetrable, and it had shattered them in a way that nothing short of such heartbreak could have. What was left beneath the believed loss of love was the very love he was seeking. In his heartbreak and amidst his failure and loss, he was actually experiencing a real Love that was anything but ordinary. The great

Persian poet Hafiz said that loneliness can ferment and season the human heart in a way that even few "divine ingredients" can. Here was the evidence. It was not his years of meditation that made this man so full, but the cracking of his very human heart—the loss of ordinary love and the discovery of something more extraordinary.

Love will fail according to our ordinary definitions of failure because human beings will fail. There is the classic story about the woman who was looking everywhere for the perfect man, but when she finally found him he wasn't interested in her because he was looking for the perfect woman. When people do not accept their own failures, when they do not open to their own weaknesses and allow them simply *to be there* instead of trying to hide them, they cannot allow others the same. When we insist upon some idea of success, particularly in the arena of love, we quickly begin to demand that our husbands/wives/partners act in a certain way, respond to us in a specific way, and animate some qualities and not others. We begin our attempts to mold and manipulate them according to our own bias about what a successful partner looks, acts and talks like. In fact, we often become more interested in our success in love than we are in the human being standing in front of us. So again, it is not that love fails but that we fail in our understanding of love and our ability to enact it, and until we accept that about ourselves, our relationships will continue to disappoint us.

Even if we are unaware of it, all of us feel an essential hunger and longing. For some it may simply be experienced as mild discomfort, a nagging feeling, an anxiety, or an

obsessive relationship to food, work, busyness, or some other addiction; others experience it more acutely in the form of loneliness, sorrow, or as spiritual longing itself. This hunger *is* the longing of the soul for God, but so easily becomes misunderstood as the longing for sex, or to love or be loved, to adore or be adored. We are so hungry for God or Truth, but simultaneously and unconsciously so devastated by the distance that we perceive between ourselves and It, that we instead take an idea of love, or the person of our lover, and place our longing for God onto that idea or that person who seems a little more accessible than God does, but who cannot help in the end but to disappoint us. In this way, ordinary love will always fail us. Despite the perfect situation—an attractive, loving man or woman full of passion for life and for us, an admirable personality, a beautiful child or two created between us—we still feel that something is missing, though we may not have a name for it. And, what often happens at this point, particularly after many years of not understanding this unnamed feeling, is that because we have been in love and in relationship for so long and yet our hunger has still not disappeared, we begin to doubt the relationship itself, certain that if it cannot fill our longing that it must be missing a crucial element.

Hundreds of thousands of people divorce yearly because their husband or wife is not God. People divorce because their husband or wife was unable to quell the maddening longing for God or Truth that is hidden so far beneath the surface of consciousness that they don't know it's there, and because they could not come to terms with the fact that the notions of love they had invested so much in were failed ideas. What a shame that we cannot understand divorce for what it is. Instead, divorce and separation take on a hundred thousand different names of, "He wasn't

enough ___," and "She just wouldn't change ___." Of course, in many instances people do fall out of love, and relationships do have valid reasons to end. But, if we do not understand the roots of our real suffering and longing, and if we do not know how to place the love of God/Truth in one category and the love of a human being in another, then we may easily become confused as to what we need to look to our partner for, and what we need to look for in God or within ourselves.

The beauty of the failure of our ideas of love, as is the case with all failures, is that we might finally be motivated to discover another kind of love. Sometimes we have to fail at love a lot, to endure great heartbreaks and become quite desperate even, before we will look further. But, when the failures look the same year after year after year, it finally becomes difficult to continue to blame life for failing to give us love. This is the crucial juncture at which the failure of love might finally prompt us to step onto a different, though unknown and maybe even dangerous, path; a path that suggests the destination of a different kind of love.

To cut to the punch line, we fail at ordinary love because we do not know how to love. We fail when our so-called love is actually want, need, desire, grasping, ideas and projections, or any one of the infinite distortions of imagined-love that human beings frequently substitute for real love. We fail when we expect love to come to us on a silver platter, to be easy, to conform to our ideals. We fail when we demand to be loved, when our definitions of love are rigid and limited, when we assume to know and perceive the many ways and means by which love is perceived.

The strongest antidote to a lack of love in our lives is to start loving. This may sound simple but is worth considering deeply. Most of us mope about complaining that we have not found the right one to love, or that the one we believe we love cannot or does not love us well, or that we don't like the size or flavor or shape of the love within our lives. We lament our losses and lick the wounds of our sorrows instead of doing the very thing required to change the situation: loving.

The work of loving is hard work. It is easier to dwell in the woes of lost, unrequited or unfulfilled love than to plunge into the often terrifyingly vulnerable waters of risking love. For love is a risk. At least at the level of appearances, the love we offer can be rejected. It can hurt to feel love, because when we do, we also often feel the thousand pockets of hidden pain we have from all the love that didn't happen, or loves lost, or the ways that we were once wounded by love. Often, to love requires that we open our hearts, and in the open heart there may exist untold quantities of heartbreak, longing, and even objective sorrow for the pain of our own lives and that of humanity.

When we *love*—as opposed to trying to get love— then love is present. It sounds so obvious. If we want love and then we start loving, we experience love. We may think that we need a certain kind of love from someone else in order to experience love, and if we believe this strongly enough then we won't even recognize the experience of love if it slaps us across the face. But, when we broaden and relax into a wider possibility of how love may be experienced, we will often discover that, when we know where to look, love is neither a substance that is in scarcity, nor is it difficult to find. Love is *available*. What a relief!

how do you force yourself to love someone suddenly??
whom do u find to love??
what if nobody needsour love??

—22—

In the end, it is self-love that we seek. In one of my complaints to my teacher about the lack of love in my life at that point, he responded, "So you want love? No amount of outer searching will ever give you love. Love yourself and you will find, feel, know, and draw love in and around and from all things."

Self-love has a selfish side and an unselfish side. Or we could consider it as the distinction between an egoic improvisation of self-love versus authentic self-love. Egoic self-love is a kind of self-aggrandizement. The ego, or self-image, loves the ego. It is the story of Narcissus. It is the process of creating an elaborately adorned sandcastle and then believing ourselves to possess our fortress. Of course this is not real self-love at all, though it is often misunderstood for it and taught to the masses through many of the common therapies.

Real self-love comes from a profound self-acceptance. It involves seeing with great and ruthless self-honesty the actual state of who we are as we are situated today; of understanding the forces that formed us as we are; of realizing that whereas we are fully responsible for the weaknesses we enact, we are not the original cause of them; and then of forgiving ourselves such that we accept the whole of our current condition, including our strengths and weaknesses. When we love ourselves we are not preoccupied in trying to steal morsels of love from any available perceived resource. We know that there is enough love inside that we can finally begin to share and exchange that love.

When we love ourselves and therefore naturally extend love to others, more often than not the very love we once so hungrily pined for comes gushing into our lives. Romance, friendship, children, material objects, and oppor-

— 23 —

tunities are likely to be attracted to us in grand quantities with surprisingly little effort. The search for love lies beneath the endless searching for all the things in life that are bound to fail us, and if we've got love, everybody and everything is going to want it.

With some genuine understanding of the real ways of love, and sometimes even before, we might glimpse another shade of love—one that we could call Divine Love, and its companion, Divine Longing. Though we may discover tremendous fullness in our capacity to perceive and receive love from all of life, the love affair with the Divine is infinite in its immeasurable depths and thus will paradoxically leave us in a state of longing even when love has somehow been attained.

The mystical Sufi poet Rumi, an exemplar of Divine Longing, has gained enormous popularity in contemporary times. People revel in and expound upon his words of ecstasy, wonder, bliss and union, and those who look deeper into the poems even whisper excitedly about his craziness and his broken heart. But, if we dare to touch the essence of the man whose ecstasy we are so inspired by, we see someone who at times was literally *mad* with devastation, loneliness, and betrayal. He had met God in the form of his master (or we could say that he encountered the absolute wholeness and completeness that we all yearn for) and then his master left, or the experience of wholeness disappeared as soon as it arrived, leaving Rumi a wandering madman, writing the poems that touch our souls. His longing was his love. Once upon a time Rumi was probably just a macho, sexist Arabic man with some good karma to back him up. Yet, what Rumi

did was to allow his consuming passion for love itself to become longing, instead of a disappointment and psychological betrayal that would leave him the victim. Similarly, in the famous love story of Layla and Majnun, the unconsummated love between the young lovers became so overwhelmingly devastating as to become longing for God alone, such that when the opportunity finally came for their physical union they chose the love inherent in longing over the consummation of their human love.

The failure of love, even in the context of a working human relationship, is fertile soil if we can bear its tenderness, for it takes us deep within ourselves. When we have admitted to the failure of ordinary love, then we begin to hunger for another kind of love—a love that need not be requited by another person, or perhaps not even by God Itself. "Love in separation" is how it is spoken about by the mystics. It is the experience of love in the longing for love, which has the capacity to bring a human being to his or her knees, and to give birth to qualities of human experience such as tenderness, mercy and wisdom.

CHAPTER 3

THE FAILURE OF (CONVENTIONAL) HAPPINESS

OUR INSISTENCE UPON an ideal of conventional happiness is often what prevents us from discovering true happiness. Human beings do a strange thing: they pound on the door marked "Happiness" begging for a morsel, when all the while the smallest shift in their inner vision would bring them a banquet of contentment, more than they would ever have hoped for. So it is that when conventional happiness finally fails us, we may at last be motivated to search elsewhere for something real and lasting. This motivation is the unopened gift of the failure of conventional happiness: that it may pave the way for genuine happiness. Whether it succeeds in doing so or not depends entirely upon us.

Strange and interesting, the way human beings insist upon happiness as if it was their birthright. We somehow feel that it is the universe's obligation to make us feel good all the time. Even those whose psychological habit is to feel undeserving carry with them a profound sense of entitlement. They feel that they came into the world, they paid their dues of an unhappy childhood and decades of education, they tried to be a good person, and thus they deserve to be happy. When conventional happiness eludes them,

and they do not feel good all the time, they tend to assume that either they themselves are doing something wrong, or that the universe is betraying them. They believe themselves to have failed.

Sometimes it is easier for people to think it is their own fault that they are not happy, because then they get to have the illusion that they can possibly *do something* in order to be happy more of the time. In the mainstream, this illusion would lead them to go on the dream cruise, or buy the Camaro or the three-bedroom house. For some it involves a beautiful blouse, or a beautiful mistress, or a beautiful ring. For the more trendy psychological types, it involves going to therapy to build more self-esteem, or empowering oneself to make more money, or attempting to become famous, or successful, or charismatic, or whatever form of psychological relief the person imagines will take them out of suffering and into greater happiness. For the spiritual types, the game is still trickier as they attempt to wield the forces of energy and mind in order to manipulate the universe. But, in the end, it is all the same. We blame ourselves for our own unhappiness and set about to control our lives to make things feel better. This is not to say that any of the above techniques are not successful and even useful in some circumstances, but instead points out some of the strategies we enact to try to get the universe to make us happy.

Other people find it more convenient to blame the universe for their own unhappiness, often spending their whole lives pouting about the unfairness of God. Underlying their whole lives is a feeling of anger at God for having given them a raw deal (understandable, looking at the way life is, huh?), as well as a sense of distrust in the universe because things didn't work out as they had hoped.

They feel a profound sorrow that they don't really understand. "What went wrong?" they wonder, still grasping their expectations for happiness.

The Way of Failure invites us to consider two very distinct questions: first, Who the hell gave us the idea that we were supposed to be happy anyway? and, second, What is this so-called happiness we so insist upon? We must ask ourselves if we have really failed at happiness or if we have simply attached ourselves to an incorrect idea of happiness—an idea that fails *itself*!

So who gave us the idea that we were supposed to be happy? Simply speaking, the answer is primarily the consumer economy of the Western world, backed by the United States government. We got this idea from every TV commercial we have ever seen, every billboard we have ever passed on the highway, and every advertisement we have studied in every newspaper and magazine we have ever read, even those we don't remember even looking at. The international consumer market has been constructed entirely upon the ego's incapacity to accept the reality of human life as it is, and to instead insist upon an ideal of conventional happiness that will never be fulfilled, thus always leaving room for an expansion of the "market of promise." We in the West live in a culture that is built on dreams that take little of reality into account, and that is run by a cadre of intelligent but unwise men with a lot of money sitting in very high places. We cannot win the happiness they promise. Just as the slot machines in Las Vegas are precisely formulated on a losing proposition—to pay out only a fraction of what they take in—the cultural system is

specifically designed to give us just enough pleasantries to keep us believing in the possibility of happiness, while ensuring that we remain in a no-win situation. Once again, this kind of happiness will never satisfy us and will always fail us, beckoning us to turn elsewhere for something authentic and substantial.

Whereas the neurosis of conventional happiness is quickly spreading throughout the world as a result of the present age of communication in which we live, the expectation of and insistence upon personal happiness is not universal. Many Asian cultures, for instance, are based on the idea of self-sacrifice—of relinquishing one's personal happiness, wishes or even life in favor of the needs of the family or the culture. Similarly, the paradigm for women in most cultures does not include their own fulfillment, but instead entails suffering in whatever ways are necessary in order to ensure satisfaction for their husbands or children. Sometimes these cultural norms are as life-negative as the narcissistic norms in the West. But, in traditional cultures that were more in harmony with the earth, there also tended to be a greater honoring of the polarities of light and dark, joy and sorrow—both within as well as without. Sorrow, pain, depression, and deep inward searching were given equal value to success, gain, power and winning.

We as Westerners express an enormous array of positive qualities—confidence, individuality, personal power—and at the same time we cannot deny the degree of our self-centeredness and self-obsession. Wounded from a childhood in which our natural joy was squashed and our uniqueness was forced out of us, we learned that if we did not take care of ourselves and make our own lives work, nobody was going to do it for us, at least in the way we really needed them to. The failure of our parents (and this

includes almost *all* parents in the West, but only because of the previous failures of their parents, and their parents . . .) to acknowledge us for who we are, led us to become obsessed with seeking validation at all costs. The Western wound has gone to bed with the ego in order to produce a culture of excessive self-obsession to the degree that we demand our own satisfaction even at the price of another's suffering.

Of course, nowhere is the demand on the universe to give us conventional happiness more apparent than in the world of contemporary spirituality, as spiritual seekers are often the most narcissistic of all. Masses flock to teachers, meditation practices, therapies, visualizations, and every kind of self-improvement tactic under the sun because they think that if they give something to God or Truth, then God will in turn give them something that makes them feel good. We certainly don't undertake a spiritual life for God's sake— at least for the first twenty or thirty years of practice—but instead our initial interfaces with spirit almost always have far more to do with our own dissatisfaction and the belief that spirituality will give us greater satisfaction. Those of us who have seen through the failure of worldly addictions will often engage spirituality as yet another more refined drug— a dose of natural ecstasy to escape from the all-too-ordinary challenges of daily life. (The failure of enlightenment itself is the subject of Chapter 11.) This drug does not work. Happiness will never come from without, and an authentic spiritual path will expose our wounds, not anesthetize them.

As to the second question, what this quality of happiness we are moving toward actually *is*, we are fortunate to have had the great mystics and practitioners from all the

spiritual traditions do the initial groundwork for us, probing their minds through thousands of years of meditation and other disciplines in order to separate the chaff of neurosis from the wheat of reality. They have explained that conventional or "egoic" happiness basically consists of a conglomeration of positive mental sensations, otherwise known as emotions, that are strung together in such a way as to keep the emotions' chemical output consistent enough to release a fairly steady flow of "happy hormones" in the brain. Of course, not all have consistently positive conglomerations. Thoughts and associations based upon conditioning from the specific events in our very early lives, combined with our interpretations of those instances, trigger many different unconscious mental and physical processes in the body. Depending upon our own constitution, we will develop a tendency toward feelings of happiness, depression, anger, or something in between. When we refer to happiness in its conventional sense, what we are unknowingly referring to is this physical and unsentimental process.

Seen from another angle, we tend to think of happiness as what occurs when the circumstances of our lives manage, for a time, to line up with our expectations. We may have always imagined that if we found the right husband/wife, had a kid, and paid off our mortgage that we would finally be happy, so when and if this situation manifests itself, we may find ourselves happy . . . for a time. Unfortunately, this amount of time is usually uncannily short, and only lasts until the next layer of desired circumstances arises and grabs hold of us. In this way, happiness is an idea—a mental construct—and when our idea is confirmed by external circumstances, then for a time we have a concomitant idea that we are happy.

There is a distinction between the emotion of happiness, as described above, and a much deeper happiness that may be more appropriately labeled as contentment. The emotion of happiness is based on mental constructs, whereas real happiness, or contentment, arises from a willingness to enter fully (heart, body and mind) into all of life experience, just as it is. Throughout the book you will find hints at this contentment, an experience that rests totally outside of life's inevitable failures. It is within this domain of contentment that all of our apparent failures are transformed into undeniable successes.

When our happiness is based on our desires, we place the whole of our contentment at the whim of forces we can neither understand nor control. If we compare life to a game of cards, life gives us an ace of hearts or a king of diamonds one day and we are full of confidence and good intentions, but then it gives us a two of clubs or a four of spades the next day and we want to quit the whole game. If we are unknowingly submitted to our desires and emotions, instead of surrendered to Life, we will simply be dragged along in reactivity to the random deal of the cards, with little sense of personal dignity, rootedness or confidence in either the game of life itself or our own ability to play through it.

Most of us cannot and do not wish to let go of our insistence that all of our desires be satisfied, in spite of all the good spiritual press this "letting go" receives. In fact, we need not and should not let go of desire itself, but instead become more balanced in how we relate to it, knowing very well that desires will not all be fulfilled and we will often be disappointed. We have to cultivate and solidify that force within ourselves that does not depend upon the fulfillment of desires in order to affirm our basic goodness or even

"okayness." Then we can enjoy the fulfillment of desire when it happens, without getting fully carried away with ourselves and ending up with a head so swollen it can no longer think straight. We can also be all right with life even when it doesn't give us the happiness we want. In fact, we may even find something very interesting in the process of not getting what we want.

The answer to the question of whether or not it really matters if we are happy is one that nobody but ourselves can provide. I think it is fair to say that almost everybody would *like* to be happy—for even those whose life habit it is to continually sabotage any potential semblance of happiness still long for deeper fulfillment. Yet, happiness is not the priority for everyone for many reasons, and not only for "neurotic" or unempowered reasons such as feelings of undeservedness or the need to squelch one's own joy to make a husband or lover or somebody else happy.

A community of monks was meeting with a reporter who was interviewing them for a popular magazine. The reporter asked each of the monks, "Are you happy with what you are doing?" The monks in turn answered in the style of, "Sure I'm happy." Or, "It can be difficult, but it's rewarding." Or, "Sometimes." Finally one of the monks told the reporter, "What we are doing here has nothing to do with happiness. We are fulfilling the calling of our souls, and you could call that happiness or call it sorrow and it wouldn't make a difference in the world. The question is irrelevant."

Similarly, a great Western spiritual master was approached one day by a female seeker who asked him, "How are you?" With the intent to teach her, he responded,

"What does it matter how I am? The only thing I care about is if my students are being served."

The point is that happiness is not the end-all priority for everybody. Some people are satisfied if they are able to raise a child consciously with the best of the love they have to give, in spite of the personal sacrifices required. Some people are content if they make a contribution to the world through their work, their art or their music. Some will choose to die for their country or whatever their cause may be. Others, like those with terminal illnesses, are often grateful simply for the privilege of being alive. Happiness is an unexpected gift when and if it arises. The failure of conventional happiness does not necessarily represent any real failure, and may be a necessary juncture in our explorations of a deeper notion of success.

Conventional happiness itself will allude us. Even if we get it, it is not real happiness, and we will always be aware of that somewhere within ourselves. At the same time, the attempt to seek out the happiness we crave is an entirely legitimate and plausible path to tread—particularly for those who can do it open-eyed. No matter how "spiritual" we are, we don't *really know* that the things we imagine will give us happiness will not in fact give us what we so avidly hunger for. Most of us simply have to experiment with trying, and hopefully getting, those things we are sure will make us happy, and then seeing what happens. For it does not matter how many times somebody tells us that finding the right man or woman, or the right job, or the right holiday will not make us truly happy and will at best only divert us. Because human beings rarely tend to grow solely from good advice, we have to live out these experiences for ourselves and assess the data that we collect *wisely*.

"Wisely," of course, is the key. We will not get our answers simply by failing at conventional happiness, feeling victimized by it, cowering from our feelings of disappointment, and going for the next hit. We will instead remain tightly in its grips, and our failures will provide us only with further confirmation of our beliefs of why we cannot be happy. The failure of conventional happiness is only a "successful" failure when we are willing to recognize and understand our failure for what it is, then to think about it clearly and experience its inherent disappointments, and finally to learn something from it. Our failed happiness is our key to real happiness, but once again the door is well-guarded and reserved only for those willing to enter a room that is unfamiliar.

Is our plight for happiness entirely doomed or not? It is safe to say that our search for conventional happiness will be disappointed sooner or later, even if it takes us until death to really understand this. As for real happiness, there remains some possibility for its fulfillment, but only if we are willing to let go of our previous definitions and approach the subject from an entirely different angle.

Even the most non-spiritually-oriented, conventional householders in middle-America recognize the face of the Dalai Lama, and cannot help but wonder at his smile and perhaps be touched by his tangible radiance. The same radiance is true of all the great ones—whether it be Mother Teresa, or your wise old grandma, or the local rabbi. The faces of the wise ones show the radiance of contentment, of fullness, of genuine concern and love for others, and even what we can safely call happiness.

But what is it about these individuals and their lives that gives them this quality? Do we honestly think that they have led lives in which all of their desires have been fulfilled? Do we really think Mother Teresa *enjoyed* wiping pus off the wounds of lepers, or that old grandma's marriage was blissful for every day of all the sixty years that she and grandpa were together, or that the old yogi in the cave who appears so radiant didn't get extremely hungry and cold and uncomfortable the first fifteen years he sat there? All of these individuals have suffered, and I would dare to say they have been willing to *feel* their suffering far more than most of the rest of us. In fact, it is the job description of the saint to suffer for the universe and not to zone out in rapture and bliss. The great ones are full of contentment from their love for and servitude to others, not because life made the circumstances of their lives easeful.

The quality of happiness we find in the known and unknown great ones results both from their willingness to be in relationship with the whole spectrum of life—including all of its pleasant and unpleasant individuals, emotions and circumstances—as well as their acceptance of each thing as it is. They are radiant in their willingness to open themselves to life, and in this they find their happiness in things *just as they are*. In other words, they are not radiant because they are happy about any *one* thing or another, but because they accept *all* things, including that which they do not like and are in no way "conventionally" happy about. They win through a full acceptance of difficulty and loss in their lives.

The contract of life does not include, and has never included, a clause for happiness. Our birthright is our aliveness, and our possibility is the fulfillment of that aliveness within the context of Truth. But the experience of aliveness and that of happiness are not one and the same.

In case this has not been clear, it is very important that in coming to a more profound understanding of happiness we do not then discount all conventional happiness as "lower," "illusory" or unimportant, as we spiritual practitioners are wont to do. We should revel in our good fortunes and delight in our happiness. When we fall in love we should do so wholly and without holding ourselves back in dread of the end of the honeymoon, and when we are full of love for our child we should embrace those moments as a precious opportunity for celebration and expression. The failure of happiness has nothing to do with denying ourselves the delights of the splendid spectrum of experience that human life offers us. Instead, it is about understanding happiness for what it is, no more but certainly no less, and in so doing learning to be in relationship with our experience so that all of it, and not just the "happy" moments, becomes fertile ground for a far deeper sense of contentment and fulfillment in our lives.

Although we would like it to be otherwise, the fact of the matter remains that most of us are not happy most of the time. Sure there are plenty of New Age "drugs" (not in the literal sense, but in the sense of manipulating internal and external energies and re-vamping of ancient techniques to satisfy neurotic psychological needs) that can keep us flying high for a very long time, leaving ourselves and others quite convinced that we are free from suffering once and for all. But, particularly for those willing to engage a life of integrity and ordinariness that involves not only their own

circumstance but a deep sense of regard and concern for the humanity of those around them, such "happiness" is only one element—though a very pleasant one—amidst an array of the challenges of daily life.

Paradoxically, it is the failure of conventional happiness that propels, if not forces, us into the possibility of real happiness. When everything is going along as we want it to, we will almost always simply enjoy the ride of good fortune and often even unconsciously avoid any situation or person that threatens our good feeling. It is usually only when life doesn't give us what we think we want that we are willing to look more deeply into ourselves in order to understand our predicament. Unfortunately, for most of us it is suffering and not joy that propels us into greater wholeness.

CHAPTER 4

THE FAILURE OF
(WORLDLY) SUCCESS

I FOUND MYSELF in an unexpected situation some time ago. The scene was the Las Vegas Convention Center— a two-square-mile concrete box devoid of a singular window and filled with thousands of tradeshow booths blasting repetitious versions of digital sound. As a favor for my friend who designed a million-dollar booth, I served wine, beer and Swiss chocolates to approximately three hundred rich, middle-aged, international businessmen for about twelve hours a day over a five-day period. As the days went by and my friends and I served these men with all the compassion and integrity we could offer, those who were even mildly conscious began to suspect that, despite our service role, we might actually have something to offer to them in terms of humanness. Finally, on the last day of the tradeshow, the CEO of one of the largest companies in Europe walked into the waitresses' room at the back of the booth, pulled back a chair, sat down, and began to talk to me. He told me how, in spite of having achieved the money, status, power, position and privilege granted to a rare few in the world of business, in recent years he had begun to review his life from the perspective of what he had contributed to life itself, and had come to the recognition that

it amounted to very little. To be in his position, he told me, he had essentially had to sacrifice the vast majority of his time, resources, passion and creativity to his work, and all it had amounted to was that some random company that he happened to be associated with had become richer at the expense of poorer companies going bankrupt. He had gambled his life for money and power, and had indeed found those things, but had won little else.

There is nothing inherently wrong with success in the business world or in any other. The experience of power or success in worldly terms can provide enormous surges of exhilaration or accomplishment. A new car, a raise, a promotion, being in the position in which you can command others and have them defer to you, being the wife of a rich or famous man, or the mother of extraordinary children, are all variations of worldly success, depending upon our definition of it. And if our successes make us feel good, or worthy, or important, then we should by all means enjoy our good fortune. In most cases we have worked very hard for our gains, and they can provide us with valuable opportunities and experiences.

Furthermore, if we are going to be either a worldly success or a worldly failure, why not be a success? If we are going to continue suffering through the emotional dramas that mark our existence—which human beings continue to do—why not do it without worrying about how we are going to pay rent or what will happen if we contract some life-threatening disease and don't have health insurance? If at all possible, we should use all the legitimate means available to us to succeed in the world in which we live. We need to understand, however, that even the greatest pinnacle of worldly success offers no guarantee that the heart will be satisfied.

Much like the desire for conventional happiness, the dream of worldly success—whether we imagine that to take the form of riches, fame, recognition, or a life of comfort—is a constant appeal to the ego. Even if our dream of success simply involves a cozy little log cabin, a low paying but fulfilling job, and resources enough to go on long meditation retreats, it is still another version of the same dream. When we have not had the experience of worldly success—whatever we imagine that to be—the ego can and will cling to that ideal as yet another possibility to escape the Way of Failure and to evade our disappointment in life for not turning out the way we imagined it to be.

It is interesting to reflect upon the life of somebody like Leonard Cohen—the poet and musician who achieved heights of success and recognition for his work over many decades. He is a man who could, and did, possess any woman he wished to, who commanded the publishers and the record companies to produce his work *his* way, who was idolized, and who had all riches and privilege.

Cohen now lives in a sparse and chilly cottage situated within a small, remote Zen center in the rural mountains of southern California. He is the cook and attendant for a five-foot-tall, ninety-two-year-old Japanese man who is his teacher. Cohen wakes up at 3:30 A.M. to spend hours sitting with his back erect, observing the endless flow of arising neuroses in his mind while somebody occasionally whacks him with a stick when his meditation posture relaxes. The rest of the day he cooks and serves food for the old Japanese man. Although Cohen was in a relationship with Hollywood actress Rebecca DeMornay, and entertained millions; although he had crowds of groupies pledging their devotion,

adoration, and flesh to him, he still chose to live in a cold wooden cottage attempting to live selflessly in spite of himself. He does this not because he is masochistic, but because he walked the path of worldly success and failed—not by the world's standards, but by those of his conscience.

We can envy people like Cohen. He has had the opportunity in this life to fulfill desires that most of us are never able to, and in so doing was able to consciously experience—as did the old businessman I spoke with—the unqualified failure of such experience to fulfill him in any deep and meaningful way. Such people have had the occasion to taste the juices of power, the thrill of fame, and the adrenaline of importance and position. They have had the opportunity to live out their dreams, to see the substance of which they are made, to find out if they bring fulfillment or not, and to discover what is gained and what is lost in their achievement.

Arnaud Desjardins—the famous French filmmaker who later became a spiritual teacher—describes this process as, "freedom by knowing that I know." He tells a wonderful story about a time in his own *sadhana* (spiritual work) when, in spite of the strength of his practice and irrespective of the fact that he was married and had a young child, he was struggling intensely with desire—for women, power, fame. One day he went to his teacher, Swami Prajnanpad of India, telling him of his desires.

His teacher, who referred to himself as Swamiji, said, "Swamiji knows that you can express yourself easily. Why don't you become a politician? You could easily become a member of Parliament and get some power. And you are in love with a famous movie star and she is in love with you [which was desperately true of Arnaud's situation at that

time]. See what happens if you go marry her. Then after that go get some more money, some more fame."

Knowing he had to live these things out, Arnaud had an affair with the woman but also witnessed that his five-year-old son could not understand what was happening to his father, that the atmosphere in his home was not the same, and that there were difficulties in his new relationship as well as with the old one. He then went on to experience notable material success in his pursuits of money and fame, and in the end found himself steady in his practice and once again living with his wife and son. For the type of person that Desjardins was, he had to *experience*—consciously and within limits—either the victory or the failure of his imagined success. It was not enough for him to imagine the various outcomes.

Those of us who are not so fortunate to receive the experience of shining brightly in the sky of society will usually continue to insist in our unconscious minds that if we only got THE THING—whatever thing that is—that this would indeed complete us in some way. It is extremely hard, if not impossible, to convince a ravenous mind that the thing it craves will not satisfy its hunger. Most people squander their whole lives reaching for the next thing, believing that perhaps they were mistaken about what "thing" it was that would make them happy instead of considering that maybe *no-thing* would or will satisfy them. More often than not, we simply have to continue to strive for the success we want, and hopefully somewhere along the path of its fulfillment or lack of fulfillment, we will learn something about ourselves.

Yet, even among those ordinary people who do find such random success, most are unable to make use of the vantage point from which they stand in order to see some-

thing new about themselves or about life. Many lottery winners, instead of becoming powerful or charitable individuals, are known to go bankrupt and become extremely depressed, if not suicidal. Runway models or star athletes always age out of their professions, yet often cling to their fame and wear it on their sleeves decades later as if it meant anything about who they are as individuals. Instead of using their success as an opportunity to see themselves in yet another light, many people choose to dive further into vanity and addiction in order to ward off the potential insight of the ultimate failure of their success.

Worldly success will gain us further worldly success, but it provides no security or insurance of success in terms of our humanity. To return to the story of the CEO, in my attempt to comfort him upon hearing his story (comforting is not necessarily the productive thing to do for someone who is getting honest with themselves for the first time after six decades of life, but is nonetheless the tendency of many women), I asked him if he had had children, hoping to remind him that oftentimes the act of bringing a kind and capable human being into the world is in itself a meaningful thing to do in one's life. He proceeded to tell me that he did have a daughter, but that she had ended up following her father's influence and had become a shark in the world of big business—biting off heads when necessary in her hunger for power and success. He now only hoped that somehow she might come to some of the insights earlier in her life that it had taken him sixty years to arrive at.

What is it about worldly success that is so compelling that it drives us to exhaust ourselves and eliminate so many

other possibilities for fulfillment in our trek toward it? The drive for success comes from an empty space within us that we keep trying to fill from without: "the feeling that something was supposed to happen that didn't," in the words of renowned author Joseph Chilton Pearce.

The unconscious origins of that emptiness inevitably have their roots in childhood. Raised in a time period and culture in which parents did not know how to properly love us for who we were and had great investment in trying to mold us into who they would have liked us to be, many of us grew into the habit of endlessly attempting to prove ourselves worthy of our parents' love. To be *good enough*. In adulthood, this now-unconscious desire to prove ourselves to our parents continues to manifest, but now takes on the more sophisticated guise of proving ourselves worthy in terms of our worldly success. We unconsciously think, "If I make enough money and can own valuable things, then I'll be a valuable person." Or, "If I have a position in the company of power and prestige in which people respect me, my parents will finally see that I am worthy of respect." As will be discussed further in "The Failure of Projections," if we are set on proving ourselves to our parents (which is most often an unconscious dynamic), it does not matter if they are 60 or 160, or even if they are dead or alive. We are still trying to prove ourselves.

We also turn to worldly success because we do not wish to suffer, and "the world" so seductively promises to relieve us of that suffering through its abundant riches. We are seduced by the possibility of the American (or German, or British, or whatever) dream, oftentimes failing to look closely at the faces of those who have achieved it.

I was once being interviewed for a radio program and was discussing with the host the Buddha's first

noble truth that "all life is suffering." "Why do you say that life is suffering?" he challenged me. "When I look around I see that people are doing pretty good. Many people have houses, cars and healthy families. In this culture we have everything."

"Do you look at the faces of the people in the super-market?" I asked him, returning the challenge. "Or in K-Mart, or when they are stopped at a traffic light, or talk-ing on their cell phone or alone at McDonalds for breakfast? Or when they are unaware that anybody is watching them? I don't know what you see," I told him, "but I see suffering. And the closer I look, the more I see."

America promised a dream to its own people and to the whole of the modern world. Yet, in spite of some mod-erate success in terms of financial gain, that wealth simply does not bring with it the qualities of joy and contentment or the experience of the happily-ever-after family that the advance hype so definitively promises. Of course, worldly success may provide a certain measure of security when contrasted with obvious survival needs of those people who are starving on the streets, or terrorized by tyrannical gov-ernments, but it still fails to provide what it promised. Furthermore, many people (myself included) who have traveled to those Third World countries that are renowned for their spiritual richness or human warmth (e.g., India, El Salvador, Argentina) have noted that in spite of the fact that many people live in extraordinary simplicity and even harsh poverty, the quality of life and of joy in these places far supercedes that of the West. In terms of worldly success, these countries may be failing, but this failure does not translate to the joyless, unsuccessful *life* we imagine it will. That is because worldly success has little or nothing to do with the freedom from suffering that we imagine it will

provide, and because the possibility for real success lies in an entirely different domain.

The problem with worldly success comes not with the successes themselves, but with our wrong perceptions of the meaning of our successes and our inability to relate to them productively. Worldly success is simply what it is, but it is also no more nor less than what it is. Success in a worldly domain demonstrates a combination of particular skills and abilities, combined with some good luck or good timing. The dissatisfaction comes when we feel good about our success *only because* our social and cultural conditioning has told us that if we have, or achieve, or get whatever worldly success we aspire to, then we should feel this way or that way (i.e., happy, proud, fulfilled). If we buy into this idea and then get what we wanted—whether it be $100,000 a year salary, a promotion to the presidency of the company, or even a debut in Hollywood—we then try to convince ourselves that we are now happy or satisfied because of our accomplishment, whereas in fact it may have little or nothing to do with our actual experience.

Perhaps our success does give us satisfaction and meaning, but it is equally possible that our good fortune has brought up ambivalence. Maybe we feel glad about being able to buy a larger house or send our child to private school, but at the same time find ourselves stressed from the responsibility and exhausted from working overtime. Maybe we are angry about our newly-found success because we are only doing it—whatever "it" is—to appease our husband or wife, when actually we were quite happy working for someone else and owning two cars instead of four. Or maybe we are inexplicably frustrated about our success

because we were driven to it by some inner compulsion to create a successful image of ourselves when it is not what another aspect of ourselves needed to be content. When our worldly successes and our ideas about those successes fail, then what do we do?

If our motivations for and response to worldly success represent the fulfillment of some idea or expectation as opposed to an actual experience in reality, then we are fooling ourselves and will end up cheating only ourselves. Our sandcastle will collapse in spite of all promises, as it did for the CEO I met in Las Vegas.

Worldly success is only a hair's breadth away from worldly failure. If we take our joy or feelings of success from any particular boon that society has granted us too seriously or too personally, we then experience an equally strong sense of contrasting failure the moment that boon is withheld or taken away from us. We get the promotion and we experience *ourselves* as a successful person, then we get laid off and we feel like a failure. We marry the much-desired supermodel and are basking in the limelight of societal envy, then she leaves us and we are shameful of our instantaneous anonymity. When we invest our success in the currency of societal standards, we give that world outside of ourselves the power over our own well-being. Inevitably, it will fail and we will fail.

Recently I was speaking with a friend who is avidly studying for her licensing exams as a psychiatrist. Obviously it was necessary to pass the exams, but she was going on and on about how she felt she needed the licensing board's approval in order for her to know that she would

be a capable psychiatrist. She felt that whoever the examiners might happen to be, they would have some inherent sense of her personal readiness to help patients. I told her I thought she was nuts. Here was a woman who had excelled through almost a decade of medical school with top grades, who has had tremendous success with clients during years of internships, and who is known among her circle of highly educated friends to be fully capable of her soon-to-be post. And yet, she had created some fantasy that "the world" of the licensing board for psychiatry would provide her a kind of personal validation—as opposed to practical licensing—that really only her parents could have provided her once upon a time but had failed to do so, and that now only she could render to herself. The success of the world will always be external, whereas the success of our own humanity and self-worth can only come from within.

The failure of worldly success becomes fruitful if and when we come to appreciate our inherent self-worth whether or not we receive validation from the external world. Over time and through our continued maturity on the path of life, we may come to see that this "world," although unquestionably real in and of itself, is also created from our minds. Oftentimes any inner certainty of who we are, though intangible and invisible, is far more real than external certainty. If our failures in the currency of the society or the world propel us to look even a little bit more deeply within, then our failures have already been successful, for the interior world is where we ultimately need to be going.

Paradoxically, it is entirely possible to appreciate and receive the fruits of the failure of worldly success while still having worldly success, and in an ideal universe that is exactly what would happen. For it is not that success itself has any inherent quality of failure to it but, instead and as

with all things, it is our relationship to our success that makes it either fortuitous or ineffectual. If we need some measure of external societal success in order to feel good about ourselves, or to prove something to someone, then we have given up our own power and dignity to a random force outside of ourselves. If we can partake of the plenitude of society and culture without becoming an emotional slave to it, then success is ours whether or not "it" gives us what we want.

Unfortunately, most of us simply cannot abide in a deep sense of our own self-worth when the universe appears to be slamming the door in our face every time we try to walk into the room. Perhaps (but perhaps not) the universe is simply unwilling to give us what we want until we learn how to be at peace with ourselves in spite of what it gives us, and that once we truly accept what it has to offer, then abundance will be ours. Wouldn't that be interesting? Or maybe the universe is more neutral and random, and our only possibility for contentment is a leap of faith into the assumption that we will get what we need, even if it is not what we want, or that at least we will get *something* that we can then do with what we will. Spiritual master E.J. Gold told his students, "You can't change what is, but you can learn to like it." The point is that when our satisfaction in life is dependent upon some calculated measure set forth by society, any success we find in this domain is as relative as the standard upon which the measure is set. Therefore we could assume, if we like, that the failure of worldly success is yet another strange gift of the universe to human beings in order to propel them toward the possibility of real success.

CHAPTER 5

THE FAILURE OF
IDEAS AND PHILOSOPHY

RECENTLY, A FRIEND OF MINE told me that his ex-wife, from whom he was recently divorced, had gotten together with his best friend. The interesting aspect of this circumstance was not that they had gotten together, which is not only common but also understandable. The fascinating part is that until that point his best friend had been vehement, if not slightly militaristic, in his stance that close friends should *never* date any ex-partner, wife, girlfriend, husband, boyfriend, of a friend. Yet suddenly, Mr. Morals himself was doing the exact opposite of what he had preached. Our ideals and philosophies will often fail when put to the test of real life.

This story is not unlike that of a former therapy client of mine whose father served as the main priest of their religious community in a cosmopolitan city. The priest was most revered by the community for his outstanding morals and ideals, while at home he severely sexually abused his daughter several times a week for almost fifteen years.

To deepen our consideration of the ways that our philosophies, ideas, and even morals and ethics will fail, we must begin to examine the origin of these ideals. Let's face it, most of them come directly from some combination of

Mommy's ideals and Daddy's ideals and the current cultural trends, which reflect their mommies' and daddies' ideas and philosophies and the cultural mores of their time, all of which are deeply influenced by the countries of their ancestry, the circumstances of their lives, and an uncountable number of individual and collective factors. In other words, our philosophies, ideas, morals and ethics are conditioned far more than they are original to us. We appear to arrive at our own viewpoints independently, but more often than not they come from a psycho-cultural-karmic program which is locked in place before we are even born! Raised within a strong Jewish culture, I am always surprised when I meet Jews from around the world, or see international Jewish theater or film, only to find that character traits I've always attributed to my own uniqueness—some of which I have even prided myself in—are strictly cultural. I might even say that they are "programmed" into my very cells.

The great Russian mystic G.I. Gurdjieff spoke about the mechanical nature of human beings, meaning what we assume to be unique and new within us—the expression of ourselves in the present moment—is as routine and predictable as the workings of a clock. Our latest personal drama or emotional upheaval may seem to be wearing a different set of clothes, speaking another language, or even assuming an entirely new identity, but a closer look may reveal its essential sameness with how we typically act or respond. While this realization of mechanicality may be an uncommon and uncomfortable perspective, if we are willing to consider the possible truth of it we may begin to see that those morals and philosophies to which we gravitate are less a function of what is "right" or "true" and more a function of tendency and conditioning.

This is not to say we should discard all our ideas and philosophies. We've seen far too many liberals, rebels and radicals fail at that one too! "Counterculture" as a reaction to, if not a rebellion against, the mass-mind culture is more often than not an offshoot or disguised variation of the very thing it claims to reject.

We as human beings need structure, we need coherence, and we need norms in order to function together in society, and it is often worthwhile to take them on loan from those we admire. Philosophies and ethics often have their roots in high ideals that were once upon a time set forth by the great thinkers or leaders of any given time. It is only important that we then learn both to question our philosophies and ideas, and also to understand their limitations.

Philosophy can be cheap if it remains locked in the mind. Easy to write, easy to read (and not even so hard to get printed!), but something else altogether to live. When we cannot integrate our ideals and philosophies into our daily lives, they may still have their worthwhile effects on our careers (especially in academia), or in providing inspiration to others who may be more capable than we are of enacting them in their lives. But ideals and philosophies also lend themselves toward a kind of mental masturbation in which philosophizing becomes an end in itself instead of a means to a fuller existence.

During my first trip to India I met a man who purportedly knew *everything*. There was not a decade in history, a religious figure, a social movement, a philosopher or philosophy, or any field of academia that he was not conversant about—modern, ancient, American, Egyptian, or other-

wise. He was a genius, and could probably out-debate many distinguished experts in any number of fields. Yet, where exactly did all of that knowledge leave him? He could barely feel his feet on the ground he was so stuck in his head! He had difficulty feeling equal to others because of his obvious intellectual superiority. The last time I saw him was the night before he left his fiancée with no warning or apparent reason. In terms of his humanness and ability to live deeply inside of his interpersonal relationships, his philosophies and ideals had served little, and had arguably counteracted his attempts at success in this domain, as he had been so seduced by his own brilliance.

Sometimes our high ideals end up being our limitations, as there is certainly such a thing as being too clever, too philosophical, or too idealistic for our own good. When we are too smart we easily fall prey to the trap of thinking our way out of things, or thinking that we know something because we can grasp it with our minds when this "understanding" is really only a compilation of facts that have no basis in our own experience. Our own cleverness fails us because it deceives us into thinking we know something that we do not, and thus we stop looking for real answers. As T.S. Eliot so accurately described, "The Nobel is the ticket to one's own funeral. No one has ever done anything after he got it." Similarly, when we are either too philosophical or too moralistic we tend to judge situations based on a preset and often rigid set of beliefs or standards, thus making choices based in how things are *supposed* to be rather than in the uniqueness of how things are in the moment. Of course if we are too naively open-minded, we may similarly blind ourselves to reality. Our lives are full of unlimited possibility and at the same time destined to fail. To live fully we are obliged to maintain a balance between an optimism and openness in

regard to life and all of humanity, on one hand, and an intelligent discernment and discrimination on the other.

Most of us strive for our ideas and our daily reality to come together—to live our message in an ongoing and meaningful way—and in moments or hours we succeed. We align the actions of our body and the speech from our lips with the ideas in our mind, or we act on what we know to be appropriate for the situation instead of our personal preference, or we place somebody else before ourselves. Those who succeed consistently and relatively flawlessly in such alignment over decades or even for a lifetime are often referred to as sages or saints. But as for the rest of us, once again we fail, by and large, again and again.

Ideals, philosophies, morals and ethics set a stage of possibilities, and life serves as the epic through which we attempt to live out those possibilities, but also in which we are continually humbled in our failed attempts to do so. When we really start to engage the path of what might be called "work on self" or "personal transformation," we also begin to understand that changing our behaviors from the self-centered, self-gratifying, and/or self-destructive ones we were raised with to behaviors that are in alignment with our higher ideals is an extremely slow and painstaking process that is far more laborious than we would ever have imagined. It is hard enough for human beings to think and understand their lives and circumstances clearly, let alone to then take action according to that clarity. More often than not we end up stuck in the mud somewhere between the two.

"I'm a Zen failure," Joan Halifax told me in an interview about enlightenment. The renowned anthropologist and author who has served as a Zen Buddhist *roshi*, or teacher, for over a decade was telling me that she was a failure in spiritual life. I examined her closely for signs of feigned humility, but instantly understood that she was indeed telling the truth about herself, and in the process was telling the truth about all of us. Although she is esteemed in many academic and spiritual circles, she knew herself to be a failure. I guess that she calls herself a failure because she has glimpsed the real possibility of a life lived moment-to-moment in alignment with truth, presence, objective clarity, and selfless service to humanity, and yet knows that she fails daily, in large or small ways, to fulfill that vision through action.

Such a vision might also be termed "conscience," which is a very interesting subject in itself. To take the consideration from that of a Zen master's failures to one closer to home, I was raised in a family in which God was feared. As a child, my father received the highest ethical Jewish training available at that time through any sanctioned institution. Branded by the ancient laws of the Jewish philosophers and mystics, he definitely knew "right" from "wrong"—*in theory*. Yet the quality of parenting he received as a child—though coated in Jewish morals and laws—was extremely poor, characterized by neglect and intimidation. Thus he grew into adulthood with a tremendous tension and discrepancy between what he knew to be rightful, and the way that he had been treated as a child, along with the behaviors he had thus proceeded to enact in his life. A great clash between ideals and actions!

One of the primary sources of our disturbed conscience is that parents talk about acting one way—they philosophize about this high-minded idea or that moral

principle—and they act in direct opposition to it. When a child shows signs of some mental or psychological aberration, or a tendency toward violence, for example, we often wonder how this is so given the high moral, philosophical, or social stance of his or her parents. And yet if we could see behind the closed doors of the child's home, or sometimes even the invisible closed doors of their parents' psyches, the cause of the child's behavior would be obvious.

Everybody experiences a tension between their ideas of themselves and how they actually are, and many will admit it. They strive to be one way and find themselves doing the opposite. They imagine themselves to be compassionate or generous, but cannot help but notice the unexpected emergence of streaks of cruelty or selfishness. What people have less understanding about and compassion for, however, is the fact that our humanness itself makes it extremely difficult to do anything other than fail to live up to the ideas and philosophies we hold for ourselves. In addition to doubting whether or not they even have a conscience, most people have not yet discovered what their conscience *is*, nor how to effectively create a harmonious relationship between that force and the frailty of their humanness.

Paradoxically, our job as human beings is to try to live up to our ideals while simultaneously growing increasingly wise and realistic about our failures to do so. We will never live up to our own ideals of ourselves, because much in the way that the process of parenting is never "done" or completed successfully but instead an ongoing and lifelong course, our process of negotiating and creating balance between our ideas and our actions is not only a continual relationship, but also contains the possibility for endless deepening and unfolding. We will not get to a point in this paradox in which we can say, "I have arrived."

It is worthwhile to consider the existence of objective ideas and philosophies, as opposed to subjective ones, as well as objective versus subjective relationships to ideas and philosophies.

If we believe in Ultimate Truth, or God, which most people (save for the hardcore existentialists) do in some way, then some "objective" ideas and even morals appear to exist—ideas or morals that are essential and incontestable either in the heavenly or earthly realms. It has become popular knowledge that not only do the mystical teachings of all the great traditions largely speak the same Truth, albeit in different languages, but also that these Truths are coincident with the laws of both ancient and modern science. "Great minds think alike," it is said, and the great saints and sages of all cultures and traditions will often find themselves in close agreement regarding their essential understanding of life and humanity in spite of vast apparent differences in their traditions.

Yet, within this objective truth, there is an endless array of subjectivity in our ideals and philosophies. I believe this and you believe that, and I am sure I am right in my beliefs, and you are equally certain of your own. Most of our ideas, morals and philosophies actually fall into the domain of the subjective, yet within our own minds we treat them as if they were the objective and ultimate truth. They come from something somebody told us so long ago that we don't even remember hearing it, or from somebody who impressed us so much that we decided we would try to be like them, even though we can't even imagine their face any more. We then take our subjective ideas and defend them like a mamma bear with her cubs, and become so internal-

ly involved with our defense that we neglect to question the objectivity of our ideas as well as why it means so much to us to defend them!

The other issue regarding the objectivity or subjectivity of ideas and philosophies has to do with our *identification* with them. Not only are many of our ideas, philosophies and morals based purely upon psychological and cultural conditioning, but our association and identification with them is equally mechanical and predetermined. To say that we identify with our ideas and philosophies (or morals, ethics, etc.) means that we have come to think of them as who we are. We have assumed mental ownership of them and integrated them into our idea of ourselves such that we do not see ourselves as separate from them (an idea that will be discussed further in The Failure of Projections). Thus, when somebody disagrees with our ideas or philosophies, we think they are disagreeing with or rejecting *us*, because we do not think of ourselves as separate from our ideas. It is quite conceivable, therefore, that we could have insight into some objective idea while having a highly subjective identification with it. (A classic example of this can be seen in a bad astrology reading, or a paranoid attitude based on a genuine insight into reality). This gets very tricky because we intuit the essential clarity of our idea, philosophy, or perspective, and yet we do not know that our attachment to it is not objective. Thus we easily fall into righteousness because we do in fact have knowledge, but are unknowledgeable about our knowledge!

"Do you want to be right or do you want to be in relationship?" a wise teacher once asked his students. What are our ideals and philosophies worth to us? Are we willing to sacrifice genuine and open relationships with others for their sake? Does it mean more to prove ourselves correct

than to allow another person to feel acknowledged for their differences? Are our ideas more important to us than love? Than human connectedness? Than the willingness to question ourselves or, God forbid, to be shown that we are *wrong*? There is nothing wrong with ideas or philosophies; in fact, they are invaluable, but they will fail us insofar as we use them to separate us from what is really important to us.

Where is the success in failing to live out our ideas, philosophies and ideals? We succeed when we learn that our ideas are just ideas—no more and no less. Aside from the one or two objective ones we may have accidentally stumbled upon and gracefully integrated, most of our ideas are sets of structures that we have adopted to make sense of life. If we are lucky, we have chosen or been taught high ideals and morals. If we are unlucky, we find ourselves with more problems than necessary in our lives. But either way, our ideas and philosophies serve us to the extent that they help us to live lives of integrity and kindness, and they do a disservice to the extent that we use them to defend ourselves from the vulnerability and unpredictability of life.

When our ideas fail us, or when we fail to live up to our ideals, then we get a chance to see who we are beneath the assumptions. We believe one way, and may even preach it to all who will listen, but we act another, and we can learn a great deal from seeing this discrepancy. We learn that it is impossible to live up to all our ideas and philosophies and that we are all highly fallible individuals. We learn that we are not as reliable as we would like to think of ourselves as being, and hopefully this inspires us

to live with higher integrity while simultaneously making us more forgiving of our own and others' failures to do so. We may learn that ideas and philosophies are not always as important as we think they are—that there is genuine and real value in other peoples' perspectives, and if not in their perspectives then at least in the individuals themselves! Through noticing the changes in our ideas and philosophies over time, we become less convinced of our own rightness, less certain that the way we think now is the only way we will ever think or the only way to think, and in so doing we gain greater tolerance for ourselves and others. Perhaps most importantly, we become humbled by our own weaknesses, and this humility becomes a valuable asset as well as a strength.

THE FAILURE OF EXPECTATIONS AND PLANS

"HOW DO YOU make God laugh?"

"Tell him your plans."

When is the last time your life worked out the way you planned and expected it to? And if by chance a segment of it did happen to go as planned, did you *feel* how you expected you would according to your design? And if you did feel how you expected to, did it last forever? And if you insisted upon making it work out your way, did you feel confident that this was indeed the optimal way it could have gone?

I don't know if I've ever met somebody for whom life has both turned out how they expected and hoped it would *and* who has been completely content with the outcome. Yes, there are those whose plans are so narrow and whose intentions are so rigid that they have more or less managed to squeeze life into the elegant or not-so-elegant box they have created for it, but we all know pretty much what this kind of life looks like. It is highly structured, made-up, and pre-recorded with décor taken from *Better Homes and Gardens*, and recipes taken from *Gourmet Magazine* or *Healthy Living*. The house is the one sung about in Pete Seeger's song about "little boxes on the hillside, little boxes made of ticky-tacky . . . ," and everything is always going

"just fine." The lives of these people may indeed be going as planned (yet often they are not—for who can easefully escape illness, divorce or depression), but they are paying a high price in terms of aliveness in exchange for the success of their plans and expectations.

Aside from the privileged few who have in some way managed to either buy or finagle their lives into a desired set of outcomes, for most of us it doesn't work that way. Life rarely works out how we expect it to, and anything but short-term and highly concrete plans tend to turn out differently than we imagined. This may appear to be bad news, but if we want to succeed in life in a real way, we should be grateful for this fact.

Life in its essence is ordinary, but it is also wild, and really has no concern for the personal wishes, desires, expectations and plans of the human beings contained within it. Human beings have certain expectations of what life will give them, and constellate any number of plans and schemes around these expectations in an attempt to secure the likelihood of their fulfillment. But, as we discussed in the last chapters, these expectations are often borne from ideas instilled in us through cultural myths, advertisements and television commercials that are so subjective that there is no reason why even a most loving universe should or would care to satisfy them.

As human beings we did not create the universe and thus we cannot control it. Somewhere along the line, we as human beings (at least in the Western world) decided that we knew what was better for us than God or Truth did, and we thus set about trying to seize nature and psychologically control those around us. Our conscious or unconscious awareness of the intense vulnerability and fragility of our humanity, combined with the often-present feelings of psy-

chological helplessness and abandonment accrued through living in a culture chock-full of neurosis and abuse, have left us feeling so powerless that many of us have attempted to create ourselves to be larger-than-life itself in order to feel some semblance of power or control.

In spite of the obvious proof that life will not coincide with our plans and expectations, we nonetheless engage in a thorough effort to try to manipulate it that way. When we ordinarily think of manipulation, we think of intentional and maliciously based scheming, but for most of us the ways in which we attempt to manipulate life are subtle and unconscious to the point of appearing totally natural. Yet each manipulation is an expression of our basic distrust in the universe and in life as it is, as well as a fear-based desire to control life enough so that we can be confident that we will be taken care of.

Fortunately for us, life rarely turns out according to our plans and expectations. To use myself as an example, several months ago I was living in a small community in the Midwest, supported financially, engaged to be married, and fully settled into a life that I never imagined leaving. I had plans to work in Europe, go on vacation with my partner, and have completed a large research project by the year's end. In fact, however, I now live on a gorgeous hilltop in the hills of California, teach in a university, counsel clients who are on the spiritual path, help people manifest their writing dreams, and have nearly completed a book on the fullness of failure rooted in my own experience. What happened? My plans and expectations for life failed, and life then set up a program for me. Did I fail in my old life, or

did that life decay in order to give rise to what was to come next? Of course, no one can answer these questions definitively for anybody else, but we can see how what from one angle may appear as abject failure can from another angle be seen as utter success.

If Life obeyed our plans and expectations, then Life itself would only be as wide as our own underdeveloped intelligence, and science tells us that as we are situated today we use less than ten percent of available mental capacity. Human selfishness and self-centeredness being what they are, without the help of life's unpredictability most people would live in a little Disneyland (whether it be a spiritual one or a Hollywood one, depending upon their tastes) in which everybody worshipped them, the sun always shone, the wardrobes changed daily, the seducers and seductresses waited longingly on all fronts, and they basically chilled out and said to hell with everyone and everything else. Things might be great, it just wouldn't be LIFE.

Although expectations and plans differ for different people, let us examine for a moment some of the common ones that people tend to place onto life, many of them coinciding with the chapter titles of this book. We expect life to give us happily-ever-after love and financial and worldly success; we expect life to go as planned, to provide us with a secure home and perfect health. We expect people to be how we imagine them to be, for life to provide meaning, for God to be a nice old man in the sky, and of course if we are spiritually inclined we expect to be enlightened, to transcend our egos, and to excel in whatever endeavors we set

out to do. We may not admit to placing such high standards on life, but this is indeed the way our ideal blueprint reads.

We rarely stop to examine the nature of expectations themselves and our own feelings of entitlement in relationship to them. We rarely ask, "What am I expecting and/or demanding from this situation or from life itself?" "Where did this expectation come from?" "Are my expectations reasonable or not?" "How do I want to relate to the situation if my expectations are not met?" "Do my expectations take into account the possibility for wider and unforeseen outcomes?" By asking these questions, we can learn far more about ourselves and about the demands we place on life. We can also begin to glimpse the possibility of a life lived less in the grips of our expectations and impositions.

In some spiritual circles it is common to hear things like, "Cease to have expectations," or even worse, "There is no longer any 'I' to have expectations." Although these ideas are noble as well as essentially true, the reality of their fulfillment is neither practical nor realistic for most of us. First, all but the few saints among us cannot just cease to have expectations at our own will. We can learn to observe our expectations, to create space around them, or to hold them lightly, but we will continue to have them. And second, most of the people who think that they no longer have expectations are simply fooling themselves. They may have had a mystical experience in which they dropped their expectations for an hour or a week or even a month, but shortly after that even the one within us who has no expectations begins to expect to have no expectations, and to expect to expect to have none, and so on. We need to cultivate awareness about our expectations, but not to expect more than that!

Having said all of this, as ordinary people we cannot *not* plan our lives, nor can we realistically refrain from placing expectations upon them in any consistent way. Our capacity to plan is a creative ability if we learn to use it as such, and if we discover how to make our expectations wide enough, they too can create a space for a great range of possibilities to be expressed in our lives. The task, therefore, is to consciously reconsider our relationship to our plans and expectations, working to cultivate a relaxed flexibility about them. Paradoxically, we proceed with our expectations and plans with all of our will and effort and passion while simultaneously acknowledging the inevitability of their failure to turn out how we desire them to. We "succeed" by having cultivated an attitude toward life that is both open and allowing.

As an example of flexibility, let us return to the issue of love and marriage. As it usually stands, we meet somebody whom we fall in love with, develop or impose a previously developed set of expectations about how they should be, how they should dress, talk and act, create a set of plans with them regarding our lives together, and finally begin to pass a period of time with our new beloved in which all of our expectations and plans slowly fail us one by one. Our partner *will* have habits that annoy us, or dress strangely, or weigh too much or too little, or act immaturely or needy or insecure. They won't listen the way we want them to, or will talk too much, or won't touch us how we want to be touched. Or they will love us too much, or too little, or they won't want to marry, or they will want to marry too soon, or they will want five kids when we want none.

The difference at this point between a relationship that is full and satisfying and one that is a disaster—assuming that there is "love" between us—is that the underlying con-

text in working relationships is that life is not going to unfold according to our expectations. Instead, we create an intention, offer that intent before life, wait to see what we are given, and then diligently go about the task of accepting what is offered and creating fullness within it.

To use another example, when embarking on a new career, planning is essential, and having high expectations will encourage us to expand ourselves to be someone capable of fulfilling our desired task. If we have neither plans nor expectations, we will not succeed in our career (though we still may succeed within ourselves, depending upon what we want for our lives). Yet again, after we have done our part of the career-planning bargain in terms of education, training and promoting ourselves, we must then be open to what is offered and be willing to make whatever it is *work* for us. In this way, our plans serve to create momentum in our lives and open up any number of possibilities, but do not confine us to the limits of what we imagined we wanted or needed.

The failure of expectations becomes a point of gain and not loss when life becomes so overwhelming or confusing or insistent upon its own way that we give up on trying to control it. We become so exhausted from swimming up the stream of control and manipulation that we finally give in. Oftentimes, when we are forced to give up, we think, "I have failed," or, "I just couldn't make it work." Our own omnipotence has forsaken us and we are forced to give in to something we assume will provide us with less than we could have given to ourselves. Yet life almost always delivers far more than what we ordered.

And, sometimes we do give up on our expectations and hopes of life solely because of our own weaknesses. We hit the same wall over and over again—whether it be in a relationship, in work, or in our cycles of depression and self-pity—and finally just plop ourselves down against the wall in exhaustion, hoping that some miracle will occur and we will mysteriously end up on the other side of it. While we may feel defeated by our own powerlessness and failure, at this moment we have already done something extremely powerful. We have admitted to our own human weaknesses and limitations—which is not easy for *anyone* to do—and in so doing have silently said to a larger force, "If you want me to break through this, *you* make it possible."

There is a quality of useful humility in the act of giving up when we do it gracefully. If we give up resentfully and insist upon feeling like a victim of life, there is little grace, but there is integrity in the admission that we are unable to conquer life all the time. In our culture, we attempt to symbolize this virtue at the end of football games or Olympic competitions when the losing team or individual shakes hands with the winner or winners. Of course they may not always be genuine in their gesture, but the act is one of saying, "I failed in my hopes and expectations, but I'm willing to stand in integrity and honor in this situation." We admit to our own failure to win or for things to go the way we hoped or expected them to, and there arises a sense of dignity in that admission, for who we are essentially as human beings has nothing to do with whether or not the universe conforms to our wishes and expectations.

Furthermore, there is great truth in the proverb "Give in so as to conquer." If we apply the principles of Aikido to this consideration, we use the perceived aggression of life not giving us what we wanted it to—which is not actual

aggression but only energy—and we take that energy all the way inside of us and then utilize it to "win" through the pure strength acquired through letting go. We win by letting life win, and when life wins, the prize is an unlimited number of possibilities—particularly for the cultivation of inner qualities of being and fullness both within and without.

Perhaps life has its own expectations and plan for us, and it is our job to discover what those are and live in accordance with them instead of continually attempting to impose our will on life. "Surrendering to the will of God" is what some spiritual paths call this process of relinquishing one's own will to that of God, Life, the Tao or the Universe. The idea is that there exists a Will or a Way far greater than our own that, if we align with it, will guide our lives better than we would have guided ourselves. This Way will look after not only our own best interests in the larger scheme of things (which again may or may not have anything to do with our personal desires and wants), but will also be caretaking the greater whole and orchestrating a place for us within that which will allow us to help serve and fulfill a greater good.

The process of aligning ourselves with a greater force may also be referred to as "resonance." We attempt to allow the inner chords of our own being to sound with those of the universe. With our plans and expectations floating loosely in our consciousness, we maintain an open-eyed intention to see clearly what the universe is calling for on our behalf. We hold in awareness our own desires and known capacities, while simultaneously remaining cognizant of an element in the universe that is yet unrevealed

but potentially greater than anything known to us at this point in time.

Practically speaking, we can learn over time to read the signs of the universe. Again, this is a tricky task, for if our desire to give up our own will in favor of the universe's will is not as strong as our insistence upon the fulfillment of our plans and expectations, we can and will take any sign the universe provides and manipulate it in such a way that it tells us whatever we want to hear. Over time, however, and only through trial and error, we can learn to read the signs truthfully. We become effective readers of these signs when, once again, we learn to intend for our lives not only the fulfillment of our own needs and desires, but those of the greater good.

The design of life will undermine our plans and expectations. It is the only way that we as human beings will understand that we do not run the show. It is the only way we might realize that in spite of our own relative and very real greatness, we are not the Boss, and that whatever name we give to the Boss, it is a force to be respected and related to with a wise but unqualified honor and deference. It is in the lived expression of this realization that we are wholly successful.

CHAPTER 7

THE FAILURE OF SECURITY

WE WANT LIFE to be secure as much as we want our plans and expectations to work out. We want to live happily-ever-after. We want to decide how we want it to be, figure out how to make it happen that way, and then if we get it the way we like it, we want it to stay that way forever. We want life to conform to our wishes, to make us happy, and to protect us from human suffering. In the end, we want life to protect us from itself, and the idea of security offers us that false consolation.

The story of an old lady's preparations for the supposed Y2K computer calamity provides an excellent illustration of the false consolation of security. From what I was told, this crotchety ninety-two-year-old widow named Druria (who named her son Drewie—no kidding!) became panicked that Y2K would destroy our planet and that she would freeze and starve to death in her Arizona home. She took all of her life's savings and poured it into electric generators, water pumps for a well she had dug on her property, windmills, a three year supply of grains, dehydrated and canned foods, a wood stove and two years supply of wood, a short-wave radio and solar panels. By the time Y2K arrived, she had died of cancer.

The illusion of security is one of the reasons for the obvious failure of the American dream. The idea being that if you pay off a house (or at least have a solid mortgage), pay off your nice car (or at least have a payment plan), get your kids off to college (hopefully without a student loan), have good health insurance (the price of which is skyrocketing by the year), and have a *happy* marriage (maybe a twenty-five percent chance if we are going to be generous), then you will be happy once and for all (that is, until you get old, sick, and die). Yet, there is clearly very little correlation between that degree of security and happiness. Most people who have all those things aren't genuinely happy, though they may certainly feel a certain freedom from the fear of material insecurity, whereas many of the people who are happy or content do not have security in one or many of these areas. The point is not only that security is not secure—we all know that seemingly favorable circumstances can change on a dime—but that security does not provide us with the qualities of satisfaction that we insist upon imagining that it will. It is by coming to terms with this that we actually succeed, for we learn to be secure in something entirely different than what we imagined would provide us with safety.

We want security, among other reasons, because we don't want to die. Death is one of the most common and natural human concerns. Though many people hesitate to dwell upon this fact, human beings are generally terrified of death—even most of those who insist they aren't. In the back of our minds, we always know that the "I" that we know ourselves to be will be extinguished, "exterminated by God," some might say, and nothing we can do will prevent that.

Yet, we insist on trying to create something permanent—seduced by some notion of living forever, of not aging. Our whole culture is based on the preservation of youth, the conquering of natural forces, and the creation of symbols of immortality that will never be achieved in reality.

Have you ever noticed how silly it looks when a ninety-year-old woman has her hair died blond and wears too much makeup? Or when all the wrinkles that are supposed to be on her face aren't there because of a sixteenth face-lift? She appears almost as a billboard advertising the rejection of death. Similarly, natural disasters are known for opening people up and creating communion in the short term, but almost immediately afterwards (especially in the Western industrialized countries) such disasters are followed by an indomitable effort to create stronger infrastructures, thicker buildings, better protection, more security and a certain denial.

Survival is the primary instinct of the human organism (more will be said in "The Failure of Ego," Chapter 9) and underlies the intensity of our drive for increasing layers of personal security. Countless are the wartime stories in which neighbors steal from one another, disclosing information that will lead to each other's imprisonment or death, and even murder one another when it comes down to a situation of "kill or be killed." The mother's protective survival instinct is common to most mammals, and is as ancient as humanity. And every mother and most fathers know very well the panic they feel, often for the first time in their lives, when they suddenly find a vulnerable, helpless young life in their hands.

Our "circle of survival" also extends wider than our own bodies. Thus the apparent acts of generosity or service to those around us may not always be as altruistic as they seem. When counseling clients, I hear story after story of

individuals who have been badly manipulated, emotionally, by parents who insisted they were only thinking of the child's best interest (i.e., the mother who smothered, over-protected and over-adored her son). Our first line of survival may be our own bodies, but quickly after that comes that of our spouses, children, extended families, community, and our state and country. All of these individuals and groups are seen as an extension of ourselves and necessary to fulfill our own needs for security and survival, and thus we have a vested interest in tending to their survival as a roundabout means of insuring our own. Certainly it is natural to want security and well-being for ourselves and our environment, and do everything in our power to ensure it, but security will fail, and when it does it is helpful to know just what is failing and why it may affect us as strongly as it does.

As discussed earlier, we also want life to be secure so that we and our loved ones don't have to suffer. Nobody wants to suffer, and there are things we can do to create more *apparent* security and thus less *apparent* suffering in our lives. On a physical level we can work hard, make money, buy a nice house, take vacations, for example. Mentally we can learn to think positively or cultivate intelligence that will allow us to make educated choices. Emotionally we can work to create satisfying relationships, or utilize the help of a therapist to feel more whole within ourselves and learn to be kinder to ourselves. Yet none of these approaches is going to save us from the guaranteed but unexpected curveballs that life promises to throw. The couple down the street from me just gave birth to a

retarded child. One of my friends was diagnosed with colon cancer. My client's sweet older brother was shot in the gut by the police while robbing someone. And even short of such extremes, daily life circumstances continually bring us disappointment and suffering, continually undermining our sense of surety.

Of course there is a price to pay for creating a life and a world in which we attempt to incur the least amount of suffering possible. Since suffering is part of the natural balance of things, if we create too much manufactured comfort we imbalance the system. We pay for our comfort through a distortion of the naturalness of life, and thus end up with a life or a culture that is indisputably comfortable, but superficial to the point of lacking depth and dimension. Many people cringe at the dirtiness or the poverty or the crowded living conditions in some parts of a country like Mexico or Burma, and yet there is an organic quality of naturalness and humanness in these cultures that is hard to deny. Many Mexican or Burmese people may endure greater physical discomforts on a daily basis, but it is unconvincing to suggest that they as human beings suffer any more than we in the West do in spite of our relative "security."

Security and its accompanying image of physical, intellectual, and emotional comfort only *symbolize* freedom from hardship, from struggling, from uneasiness. I say "symbolize" because a symbol is a representation for something else. Outer and imagined security, though real in and of itself, is a symbol for an inner longing to rest in That which is truly deathless, unchanging and ultimately Secure. The inner perception of security we derive based on external experiences and circumstances can be reassuring and comforting, but it is as temporary as the duration of the situation that created it.

We must also ask ourselves what it is that we really suffer about. There is a relative form of suffering that is very real—heartbreak, poor health, difficult circumstances, hurt feelings. But there is also another kind of suffering going on, which we could call the suffering of our separation from God/Truth, from ourselves, from the fullness of our humanity. This concept will be discussed further toward the end of the book, but the point here is that we often do backbends in order to create a security to protect us from one kind of suffering and hardship, when what we are truly suffering about has to do with something altogether different.

Insisting upon security can easily lead to an inner deadening as well as great and small degrees of self-compromise and self-abandonment. Such is the circumstance of my cousin the wealthy lawyer. He feels he has missed out on what he really wants to do in life, but can't stand either the thought of having to forgo any aspect of his comfortable lifestyle, or his wife's reaction if he did! He also can't admit to their obviously failed marriage. Both he and his wife are too afraid to risk loneliness or the unknown, and so they remain within the walls of the same house, maintaining security "on paper," but unable to rest in the shelter of real love or communion.

Many people value and prioritize security over and against endless other possibilities in life, and they do this on all levels. They keep the bad job, or the unhealthy living situation, or the alcohol or drug addiction, or the neurotic psychology (for even *that* is secure), or the distant relationship with God/Truth, in favor of risking the possibility of losing what little they have in their pursuit of something

greater. If we give up the bad job, we might be unemployed, or even homeless, or we might starve to death . . . or we might end up with a brilliant work situation and a career totally unforeseen to us previously. If we give up the drug addiction, we are certainly going to be left with the morass of underworld feelings that we used it to protect, but we might also experience a great depth within ourselves as well as a quality of freedom previously unknown to us as a result of passing through those difficult emotions. If we give up our neurotic psychology—and we *do* have a choice about that— we may not know who we are and feel tremendously vulnerable and exposed, but we might also find fullness, health and harmony in our lives. And if we stop fighting God/Truth, we may indeed lose control of our lives (for that is what we are so afraid of), but we chance allowing a life of Truth itself, whatever the consequences may be.

Of course the need to risk our clinging to security should not be confused with ignoring the Sufi proverb, "Have faith in God but tie your camels first." To use the failure of security as an excuse for foolish and unnecessary risks is just another psychospiritual excuse for our own lack of responsibility. Then again, sometimes we might have to risk making a dumb mistake just to see what will happen, just for the experience of risking itself.

We further turn to security because it represents the freedom from wanting and craving. The days of our lives are comprised of unfulfilled desires. Whether we want ice cream, more love in our marriage, nicer hair, a better life, a different life, or a cup of coffee, we are always wanting. When we finally have something that is secure, we are temporarily relieved from wanting it. We finally "capture" the man or woman we desired, or secure the job we had been after, or shed the twenty pounds we have spent half of our

adult life trying to lose. Unfortunately, even when we create something relatively secure (of course we could always lose the man, the job, or regain the weight), if we look at all closely we see that this achievement only gives way to the next set of desires. We got a good job, but now we want more money for it, or to not work in such an emotionally unhealthy environment. We get the man or woman we craved, and suddenly discover many aspects of them that we feel anything but craving for. Or we keep the twenty pounds off, but our attention turns to the kink in our nose, or ten years goes by and that thin body starts to sag and wrinkle.

The imagined security of fulfilling our desires will fail because the nature of desire is that it is self-breeding. It is not that we should quell our desires, for they are forces of tremendous power and creativity, but we can cease to look to them as a source of security, as they will definitely falter in that regard, and instead look toward what else remains when our relationship to both security and desire fails us.

We turn to security because we fear the unknown. The unknown—however we choose to call it—is what we came from and is our inevitable destiny, but we are afraid of it because by definition it is exactly that! We do not know what the unknown will bring. This is a difficult predicament for human beings. The whole arena of our lives is ultimately insecure, and yet this fact is so disconcerting and unnerving that we do everything in our power to create boxes and segments within the arena of life that will provide some sort of reliability and protection. The problem with favoring security over the unknown is that security limits us. We may in fact find some security within the boxes or

walls that we create, but then our experience becomes imprisoned within those confines.

As an example of the boxes we create, I was recently discussing the limitations of certain kinds of psychological work with a therapist and colleague of mine. She immediately became teary and defensive and expounded upon the sacredness of the individual healing process, the spiritual value of psychological work, and on and on. She was offended that I, a colleague in the field, would dare to suggest the limitations of our shared work. Whereas there was nothing inherently wrong with what she said, the box of security that she had created—in this case one labeled "psychological work is healing and always valuable"—was so important to her in terms of finding security in her work that she needed to protect it at all costs, including the price of an open-minded consideration of the limitations of her career.

When we open to the unknown, we risk discovering that we were wrong, and perhaps losing face, either to ourselves or to those around whom we have tried to keep up a proud front. We may see that we have been moving for years or decades in a direction that was based on our own fears, or our own misguided beliefs, or even our own prejudices or compromised or limited perspectives. We may be embarrassed or feel humiliated by the smallness of our vision when staring in the face of what was previously unimaginable. In relationship to others, daring to move into the unknown may create friction or even rejection. Many a priest has been excommunicated for expounding upon issues of the spirit in a language unfamiliar to the church, and more than one of us has at least temporarily lost a friend, family member or job through attempting to expand the previous boundaries.

Whereas we all know and intuit that the unknown holds secrets and possibilities foreign to and beyond our present experience, we unconsciously think that if we allowed ourselves to access it, it might overwhelm us, consume us or kill us. And in some sense it will, but we imagine it will mean physical death instead of the destruction of the boxes and walls we have created to protect ourselves. It is true that what was once secure may now become insecure, but of course we must ask ourselves how secure it (whatever "it" may be) was in the first place, and what that security was based on.

When we recognize that our lives are essentially insecure in spite of the relative security that we attempt to create, then we need to decide what to do about that fact. Our options appear to be as follows: 1) we can deny the fact of the failure of security and pretend that everything is going along just fine and will continue to do so; 2) we can tolerate the insecurity; 3) we can turn toward and rest in the insecurity; 4) we can welcome the insecurity.

In terms of the first option, to deny the fact of insecurity, which is a popular option, we are welcome to do this as long as we are able to. If we are lucky (or unlucky, we could equally say) then we can live our relatively happy lives and suffer our inevitable deaths in denial, unaware that we have compromised our lives for something that will in the end turn to dust.

The second option is to tolerate the insecurity. Here we have opened our eyes to see that things are often not as they seem, or at least are unlikely to stay that way, and so we queasily endure our situation. If we are enjoying our

circumstance at the moment, we do so with the trepidation of waiting for it to change on a moment's notice, and if we are unsatisfied, we nervously wait to see if it might get better or even a little worse. Most us relate to insecurity with tolerance. We move along trying not to get swept away in our worries of, "What if this?" "What if that?" We sometimes make choices too hastily that may not be the right ones, in order to avoid having to rest in an unknown option, or cover up our feelings of insecurity with busyness, work, or any other form of distraction. Insecurity can be extremely uncomfortable and so it is understandable that we lack tolerance for it.

If we are lucky we find ourselves willing to rest in insecurity. Sometimes the lack of certainty or security in some significant area of our lives forces us to learn to rest in uncertainty. The worrying may become so exhausting that we are forced to take refuge within the current situation of incertitude. Maybe our husband or wife has been experiencing ambivalence in our marriage for a long time and we have no choice but to find some joy within ourselves and within our lives as they are, in spite of the uncertain outcome of our primary relationship. Or maybe we have a terminal disease and we must find our peace within the knowledge that our lives might be taken from us at any time (which is always true anyway). Even if things are going along relatively fine, there is almost always some element of life that will not allow us to rest at ease unless we make a point of finding respite in spite of circumstance. The act of resting in insecurity involves an internal shift *toward* the direction of the perceived source of our insecurity so that we are not always attempting to push it away, instead allowing it to take its place among all the other elements of our lives.

Lastly, there exists the remote possibility of welcoming insecurity. Whereas in the act of resting in insecurity we allow it to be there, when we welcome it we embrace it fully as an invited guest that has something valuable to offer us. The few who are willing to embrace uncertainty in their lives are those who fully appreciate the fact that, beyond the shadow of a doubt, life as we know it is essentially unstable. They know that the way to live fully is by engaging wholly in relationship with the lack of security that life promises them.

One of the valuable gifts of the lack of security is that it keeps us awake (or at least wakes us up from time to time!) to the reality of the laws of life, death and change. Insecurity is the worldly reminder of the law of change: all things are transitory, and all things will change form and die. If we are committed to living fully, and willing to ongoingly take the necessary risks to do so, the failure of security serves as a constant and welcome reminder of the reality of our own death and thus the necessity and urgency to live our lives as we are situated today and in this moment. Since we are easily lulled to sleep by what is too comfortable and too safe, the large and small moments when insecurity visits us remind us that indeed we cannot depend on any circumstance, situation, idea or even mental construct to provide us with lasting satisfaction.

The secret of the failure of conventional security is that it has the potential to push, or even force, us to rest in a wholly different domain of security. There are many names for, and degrees of, what we might call a higher security—God, the True Self, the Universe, Essence—but whatever we call it, there is one thing that is secure and will not fail us,

even if it cannot be captured, held, or even seen. We need to become aware of *That*, and make that our source of security.

I will make no attempt to define God or Truth here, as to do so would more than likely only confuse or limit the reader. Yet, most people intuit that there is some force at the source of our existence, and I believe that we have the option to trust—or even to leap with blind faith into—a confidence that there is an Intelligence to that source that is guiding us toward Itself. To trust doesn't mean that we don't also try our best to do our part in aligning with that source, or that we blindly throw ourselves into risky situations. To trust involves taking some refuge in that force, and in ourselves as an aspect of that force.

When we trust in the universe, or rest in the unknown, and open ourselves to the full insecurity of how that manifests itself on a worldly level, we are saying to the universe that we are willing to allow it to give us what it will. We are placing our security in the unknown rather than in the known. Obviously this is far more easily said than done, and in fact may be entirely impossible to will ourselves to do of our own accord, but we can make noble gestures in that direction.

And, if we cannot or do not wish to trust in the security of God or the Universe, at least we can effort to accept life as it is, a subject that will be explored further throughout the book. Since insecurity is what is real and true about life, we take life on its own terms because we want to experience life as it as and not as we are trying to force it to be. Our security comes from the fact that we are alive, and that in this moment life is just what it is—neither secure nor insecure on an essential level. Since security has failed, we take what is offered and find our contentment therein.

CHAPTER 8

THE FAILURE OF PROJECTIONS

HUMAN BEINGS TEND to project their subjectively-based reality onto everyone and everything they interact with. The principle of projection is a very real process that is continually active in our daily lives. It is also probably the singularly most important concept in psychology, and one that will help us to understand how we unconsciously create unnecessary drama and difficulty in our lives. As we gradually learn to drop our projections, we succeed in revealing and sustaining a worldview based on a clear seeing of reality as it is.

The process of projection begins early in life when the child begins to perceive itself as separate from its mother and must learn to make some sense of his or her experience. The child observes everything and begins to collect a body of impressions that leads to an internal definition of "how the world is." Because even the best of parents possess greater or lesser degrees of neurosis, the child also takes in a certain confusion and distortion about how reality is and forms his or her views of life based upon this inaccurate viewpoint. Very often, the resulting bewilderment is intolerable to the point that the child represses these feelings and buries them in their unconscious.

In this way, in order to cope with his or her confused circumstance, the child both *internalizes* this subjective reality in order to survive the pain of its distortion and confusion, while simultaneously projecting the unconscious material onto life and everything in it just as a projector relays film onto a movie screen. The inner reality that is both repressed and unconscious then becomes superimposed on the child's outer experience to the extent that it appears totally real—inseparable and indecipherable from a more objective perception of reality. The child grows into adulthood imagining all he or she sees and perceives to be real, while it is in fact an inseparable combination of the real and unreal.

In practical adult life, this process of projection often expresses itself as the playing out and replaying of various scenarios or dramas onto the stage of life. If as a child our father was abusive and our mother passive, we are likely to see as violent any tendency in a man that is slightly imbalanced or angry. If as a boy our mother smothered us with excessive and inappropriate love that should have been directed toward our father, at the least sign of a woman's doting on us we are likely to feel overwhelmed, consumed and thus reassured of our idea that "women are overbearing by nature and will try to suck you dry" or whatever our version of this dynamic is. Or, if our parents were so consumed with their own problems that they never took the time to understand us, we are likely to find ourselves in situations in which we believe nobody really sees who we are or appreciates our reality, in spite of every evidence to the contrary. The spectrum and variety of projections is endless, but the point is they exist as an integral part of all of our experiences, and that they *will* fail to bring us the satisfaction we crave if we do not eventually learn to make distinctions between projections and reality and then experience at least part of our lives outside of their domination.

Another way to consider the process of projections is by thinking of the universe as open space in which we create a series of cardboard boxes of all sizes that fill the world as it is known to us. When we find ourselves in a new or unfamiliar space, we quickly assemble another box, or move an old one into the new space. These boxes are constructs through which we organize and understand an otherwise seemingly mysterious, if not chaotic, world. Were we to live without these boxes, we would be faced with a kind of raw presence that would likely be very frightening to endure, at least initially. In fact, it is conceivable that if we lack a certain inner stability that we might not even be able to function sanely outside of these boxes. Thus they become internal structures that are at times necessary but are also inherently limiting.

We continue to sustain our projections—holding them dearly, like a newborn child, in spite of their long outdated use and even disastrous effects on our lives over decades—because once again they keep us "safe" in a very relative sense. They keep us protected to the extent that they define the edges of the container in which we live and prevent the full unleashing of our fear of the unexpected and the unknown. That is to say, if we are certain that life is going to treat us this way or that way, that "men are always . . . " or "women are always . . .," those projections will define the limits of what we are going to see and perceive to the extent that even if something happens to us outside of those limits, we will quickly reorganize our perception of it in order to defend our fort of projected understanding.

To illustrate this point, almost everybody—including the most suspicious and cynical among us—has had mystical experiences in which the domain of God, Truth, or the Unknown surfaces for a time period ranging from a flash of

a moment to an hour or more. However, because these "peaks" are so far outside of our understanding of life, oftentimes even before they disappear we begin to question or deny them, quickly proceeding to forget about them altogether. Even though in some way we all crave the mystical, we are usually unwilling to leave the safety of our projected reality even to embrace something that promises us greater wholeness and fulfillment.

Anything from the failure to have human contact with the checkout clerk in the grocery store to the failure of a marriage is often based in our inability to experience life outside of our projections. When somebody complains about someone being "set in their ways," they are usually expressing frustration that this individual is unwilling to open their projected world view to include a wider perception. The closed individual is stuck in the land of projections and has separated himself or herself from the world of human relationship.

Sometimes we are fortunate enough to get a glimpse of the degree of our projections. For many people this happens after a marriage or love relationship has failed for the third or sixteenth time for the *same reasons*. For example, if we have repeatedly left or been left by a controlling woman, we are presented with one of three options in terms of how we view our situation: 1) every woman on the face of the earth is bossy and controlling; 2) we keep choosing controlling women because our early templates have taught us that this is what makes a woman (even if we hate it); or 3) we *make* every woman we get involved with controlling. If we assume for the sake of humanity that the first option is not true, then

either of the later two choices leave us with a bad case of "projectionitis"! The point is that after we find ourselves on the same hamster wheel month after year after decade, we start to suspect that it may not be life doing something to us, but us doing something to life. And if the situation is bad enough or frustrating enough, we may even consider looking within ourselves for the source of the problem, and doing something about changing it in our lives.

This idea that we actually *create* another person through our projections can be hard to stomach initially, but is both a powerful and empowering concept to understand. To say that we create someone else through our projections means both that how we perceive somebody else has everything to do with us and what we do consciously and unconsciously within our own minds, and also that with careful attention we have the capacity to help someone else move out of their own projected *self*-image through holding a wider vision for them of who they can be.

Although every person is multidimensional, we tend to see only certain aspects of them depending upon what we put our attention on. To us, our boss may seem power hungry, manipulative and downright mean, whereas our co-worker may see him as insecure and frightened, and his wife may see him as simply vulnerable, confused, and a very good lover! Who is right? It is not just that he shows different sides of himself to different people, or that the chemistry in each situation is different, but rather that our perception has to do with our own capacity to see the whole of another person or situation with clarity and perspective. We understand this all the more clearly when our projections change, and the person whom we once abhorred—whom we had judged for *certain* as cruel, annoying or superfi-

cial—is revealed to us as warm, caring or perhaps just afraid. The "other" has not changed. We have.

The other aspect of this consideration of how we create others has to do with how we can help somebody create a larger vision of themselves. When we do this we have learned to make a true success of our projections. The most obvious example can be seen when two people are falling in love. At this point the lover often views the new love as the Beloved Himself or Herself. They project the inner films of beauty, sensuality, and even God onto the object of their affection, and lo and behold that person becomes those very things! Suddenly they are radiant, energetic, kind and open, even if they were a raging maniac just weeks before. Of course, in falling in love we are often unconscious of the dynamics of the initial projection (we call it "the honeymoon phase" and think little else of it), and then are equally unconscious that we have changed the film when we start to project attributes that are as ugly and negative as were the initial projections glorious and positive.

Imagine if we learned to exercise conscious choice in our projections; if instead of fantasizing and superimposing an unrealistic image onto somebody—whether positive or negative—we could instead allow ourselves to see more dimensions of them, and even to be expansive enough and flexible enough in our perceptions of them to allow latent aspects of who they are to emerge.

"You create your own reality" is a popular New Age slogan, and in one sense it is true. You *will* see what you believe. The problem with this New Age ideology is that it easily becomes used as a tool to manipulate and control reality. If, as it implies, all of reality is subjective and neutral, why not exploit life to give us all the money, power, and spiritual power we can get in spite of how many bodies we

have to step on or over to get it? (After all, they created their reality of being a stepping stone or a doormat, right?) If we rely solely on the idea of creating our own subjective reality, then our task is simply to learn how to trade in our current reality for a new and improved one that will give us *more* and *better* of whatever it is we want. Perhaps it is more accurate to say that reality creates reality, but we are certainly responsible for our perception of it and how we relate to it, and by forming a conscious relationship to this process we can help others do the same.

Our projections fail us because we continually lose the opportunity to see things as they are, which is what we truly want in our heart of hearts in spite of all wishes to cling to the safety and security of our minds. Our projections are the cages that once upon a time kept us safe when we lacked the capacity and support to see things as they were, but have now become the bars that keep us from the freedom of maturation into an adult vision of life that is not bound by impressions and experiences that happened so long ago as to have been entirely forgotten.

Renowned Jungian psychologist Marion Woodman once spoke about human maturity as the ability to withdraw projections. We learn how to take back the projections we place onto life so that we can see what is really there. In order to do this, of course, we must learn to see our projections, and to really do this requires far more than one or five or ten stunning insights into the nature of projections and the fact of our participation in their creation. Instead, it involves a process of rigorous self-observation that often goes on for decades of life, if not an entire lifetime, as we

slowly learn to dismantle the mechanism of projection with-in us. It is not that we must disassemble each and every projection, as some forms of therapy attempt to do. Instead, we come to understand the dynamic of projection itself, to see where it comes from within ourselves, what we were try-ing to protect, and why we no longer need to keep this mechanism operative. We observe this again and again, and slowly find within ourselves the courage to see with open eyes a life we didn't see before—with its increased fullness *and* desolation—and to maintain the vulnerability of our vision in spite of the persistent demand from within to return to the secure harbor of a safe but projected reality.

The Hindu tradition reveals the teachings of "*Neti neti*" or "Not this. Not this." This is a *sadhana*, or spiritual practice, through which over many years we come to learn "what is" by seeing what is not. Something we were certain of reveals itself as a mirage. A perception about somebody we held onto dearly exposes itself as a figment of our imagination in an unexpected moment. A clash with death (or even with life!) reminds us that we have been seeing through tinted and tainted lenses. And, in this gradual undoing, what lies beneath it all slowly begins to peak through.

The dismantling of projections is not only a psycho-logical process by which we take apart the constructs and ideological loops we have placed onto life, but can become a deeply spiritual process through which we disassemble the most basic layer of constructs that form our idea of what reality is, thereby opening up the possibility for true vision and a life that is unconditionally real. This idea will be fur-ther explored in the following chapter, but for now we can begin to glimpse both the power of our projections—whether or not we are even aware of their existence—as well as the depth of gain possible in allowing them to fail.

CHAPTER 9

THE FAILURE OF EGO

WHEN WE BOTTOM OUT on the failure of projections we are plummeted into the domain of ego, which itself is the ultimate projection. The failure of ego is about the slow and gradual process of human maturity and transformation that in the end amounts to inevitable failure —whether in this lifetime or in 100,000 eons. The failure is only the defeat of ego and its dreams of *its* salvation, but will nonetheless be experienced as a process of fairly consistent loss that will at times permeate the most guarded corners of one's life.

In dialogues about spiritual issues, the evasive and invisible structure of ego is easily thrown around but is often little understood. Ego is extremely difficult to understand. How can we see objectively the very force that defines our subjective vision? Therefore, in order to explore ego and its inherent failures *and* successes we must tiptoe between the synapses of our ordinary subjectivity, and be willing to humbly acknowledge the fact that there is much we cannot and do not see.

Ego is a construct, created by psychology and defined by a series of primal reactions and defenses that were established during infancy and early childhood. This construct

interprets reality according to its exclusive vision and creates various types of functioning intended to maintain that vision, at all cost. To explain this difficult concept further, the mass of already-existing consciousness that is constellated in the form of the human infant begins to interact with the consciousness around it and form itself in groupings that slowly create a human identity. When that identity, which we often refer to as "ego," has been constructed, it takes on a life of its own and its function becomes that of ensuring its own survival. The principal way it does this is by assuming full possession of the human consciousness as its own, and convincing the entire being (except for an imperceptibly small piece, thank God!) that the Being is one and the same as the ego itself. Therefore, one of ego's primary functions is to hide the fact of itself in order to ensure its own survival.

The human being thus goes on to assume a kind of false identity, which we call the *persona, personality*, or *identity*. (Note: This identity is not entirely false, as there are not only elements of one's essence mixed within and throughout the ego, but also because ego itself is ultimately a creation of God.) The identity we assume is not only a function of our essence and sincerity attempting to express itself, but also the result of a series of reactions to impressions gained in childhood, combined with the skillful taking on of character traits that were key to our survival. The resulting identity, or persona, was locked into place in order to ensure our survival even in the face of unexpected, dangerous or perverse situations.

It may seem as if certain character traits could not possibly be useful to human functioning—for what potential value could a violent, murderous streak have to someone? But, in almost every case, the attitude or behavior is serving

some practical value of self-preservation on *behalf of ego*, as opposed to serving life. Of course, from the outside we can see that most of these behaviors are outdated and even highly self-destructive (i.e., ending up in jail for the rest of one's life, or raping someone, or being a controlling bitch on a daily basis), but to the still immature and unconscious ego, which was crystallized in childhood, the protection is still necessary, and ego is therefore willing to enact that defense at any cost.

Furthermore, we all need an identity, and fortunately for human beings, the ego is quite in love with pleasure and comfort. Thus, the personality is often created with both intelligence—to secure the intellectual structure necessary for material survival and its ensuing physical comfort—as well as with the capacity for seduction, enjoyment and power. There are also mysterious elements of the human being that appear to have evolved primarily or solely for the purposes of unmotivated pleasure and love (the clitoris and the heart?!). And once again, we cannot deny that since the underlying source of ego is Truth or God itself, the personality or identity is ultimately created both as a block and a passageway to its own undoing.

The personality is what gets us through life. If we are lucky enough to have cultivated a relatively positive and interesting personality, our lives are likely to be more enjoyable, harmonious and satisfying. If our childhood wounds are too great, or our emotional capacity too constricted, we will probably end up with a personality that will guide us "safely" through life from an egoic perspective, but in a more choppy, disturbing, and either excessively dull or excessively dramatic manner. But either way, it is still just a personality—very real in and of itself, but also inherently empty, as it is essentially little more than an invisible and

energetic construct. In spite of appearances, the relative success of our personality in no way defines our objective worth—superior or inferior—because it is a neutral element that is simply painted with traits that are more or less beautiful to the mind of the perceiver.

If we use the appearance of our egoic identity, along with its greater or lesser capacities, to define who we essentially are, then we have failed. We have mistaken the finger pointing at the moon for the moon itself and fixated on the unreal instead of seeing the real.

No one can deny ego's undeniable success even in conventional terms. Ego is successful primarily for three reasons: protection, organization and transformation.

First, the ego greatly served us in childhood in its function of self-protection. Raised in an emotionally unbalanced culture and often in slightly or highly neurotic families, we were surrounded by forces that were simply too dark and confusing to be integrated by a child's pure and vulnerable mind. Ego created false understanding as a necessary protection from a reality that might have driven us literally crazy.

Second, human neurosis aside, ego is what helps us to make sense of things. Whereas the boxes we create will limit us if we cannot see that they are insubstantial, they do help us to categorize and organize our experience. Ego gets the bills paid, the thesis completed, the seminar organized, the household running smoothly. Ego is responsible for the vast majority of ordinary functioning.

Third, a strong ego is a powerful asset for transformation. If our egos remain weak, we are likely to remain stuck

in our lives, consumed in the activity of continually shoring up the ego and throwing it around in order to keep making physical and emotional ends meet. This can be seen in the case of somebody who is insecure to the point that all of their attention is continually tied up in looking for signs of either validation or rejection, or in trying to look a certain way, talk in a particular style, respond with the right words, so that they will be approved of by some unnamed external entity. The weak ego is far too self-obsessed with basic emotional survival issues to be bothered with considering something as seemingly impossible as human transformation.

The strong ego, on the other hand, has a certain confidence about it. Whereas its detriment is overconfidence (i.e., "I'm so great and spiritual and powerful I don't need to be transformed, or even need God, for that matter"), the strong ego can also grow in strength in the form of human intellectual and emotional intelligence—an intelligence that may become a powerful tool in aiding us to pierce the whole construct of ego itself. The strong ego has learned to survive not only on the basic levels of existence (like food, shelter, career), but has often developed maturity in terms of human understanding, relationships, conscious and positive action, and even compassion. Therefore, its attention becomes freer to engage and potentially "succeed" in the necessary-luxury of spiritual transformation. The transformational process **will** challenge the individual. Paradoxically, a strong ego is an invaluable force that will aide in allowing us to endure the demanding task of disidentification with that very ego.

Paradoxically, and as an example of the fact that there are exceptions to all rules, sometimes it is the weakness in our egoic-based personality that ends up taking us to the goods, as in the example that follows of a man I know.

Jack, as we will call him, was for many years the personal attendant of one of the most popular spiritual masters of our day. Yet, in addition to being committed to an exhaustive body of spiritual discipline and having the enormous privilege of serving his teacher's every need for twenty-four-hour periods that sometimes extended for several days, this man also had a small drug trafficking business on the side. There was a great split within his psyche that in the end landed him not as the enlightened successor to his master, but in a maximum security prison for fifteen years.

While he was by his master's side he received every kind of personal attention, individual supervision for his practice, and torrential downpourings of grace, and thus he invisibly progressed along the spiritual path. In prison he received stabbings, threats, exhaustion and mental torture. Yet, it was only in prison that the shock of the consequences of his actions, the horror of his external circumstance, and the longing for his master, compelled him to engage real spiritual practice in a way that actually made a significant and undeniable difference in his transformational process. It was his own personal hell, and not his master's one-to-one benediction, that gave him the necessary push to give himself wholly to a process that would reveal to him those insights and living understandings that he could not find even while literally being held in his master's own arms.

We would like to think that beauty and joy and ecstasy would propel us along the spiritual path at the speed of fire, and yet for most of us it is only the knowledge of our

own suffering that moves us in any significant way. "The ego does not die with laughter and caresses, but must be chased in sorrow and drowned in tears," reminds an old Sufi proverb. Joy and ecstasy usually, though not always, compel us to seek after more of the same. Suffering, on the other hand, is more likely to give us the necessary push into the risky journey to understanding the source of that suffering—an understanding that is the key to transforming our relationship to joy and suffering in any meaningful way.

Sometimes it is only seeing our own internal hell manifest in its full glory in external reality that makes us willing, or even unable to deny, an obvious reality about ourselves that is necessary to come to terms with if we are to discover any real success in our lives. In this twisted way, the ego fails only in its own intention. Actually, a raging victory is scored from the perspective of the heart's true longing.

Regardless of the strength or weakness of ego, one thing for sure is that it is here to stay! Notions from Eastern spirituality about transcending the ego or killing the ego are not only misinterpreted by Western spiritual aspirants, but also far less applicable to their actual needs. The Western ego is so complex, ultra-autonomous, and overdeveloped, that it is not going to die, and won't even go down without a hell of a fight. You can see the power and grandiosity of the Western ego by looking at any major city in the Western world, or even at the influence of the West in every country throughout the planet. The Western ego looks inside like Las Vegas looks outside. It is as likely that

ego will lay down its sword as that the casinos in Las Vegas will give half their income to charity.

When Westerners—particularly overzealous spiritual seekers, among whom I include myself—get stuck on the idea of ego death, they are likely to pass through a period of spiritual grandiosity. They will boast—either within or without, depending upon the degree of accompanying elegance in the moment—about being "no one" or "nothing." They will write their names in all lower case letters for a time (I did that one!) or, even worse, start referring to themselves as "the body-mind" or "this body," as did a man at a lecture I attended. Presumptuous statements such as these represent a gross misunderstanding of the magnitude of the task of asking ego to even take second seat, much less commit hara-kiri.

When authentic Eastern philosophy refers to "killing the ego," it is only suggesting that the ego's autonomy over the true Self dies, or that our identification with the ego—our belief that *it* is *us*—dies. Surely we must not think that when the great saints of the East talk about ego death that they are unaware of their still-existing personality. They are profoundly familiar with the degree of their own humanity, which includes their ego-based personality. In fact, it is their awareness of ego's persistence and out-and-out resistance to submission that makes the saint or master both utterly compassionate and capable of assisting others in understanding the dominance of ego in their lives. Still, we in the West toss around terms like "ego death" as if it could be bought at the corner store.

Since ego is not going anywhere, the task of our work with it in order to be successful is twofold: 1) we must learn to disidentify with ego; and 2) we must befriend it. In the process of disidentification with ego, the ego becomes the

slave of the mind instead of the master of it. Ego becomes the passenger in the train of human awareness instead of the driver. Disidentification occurs when by some stroke of luck or grace or through a diligent and deadly-honest practice of self-observation over many years, we are able to get enough outside of ego to objectively see the full mechanics of its operation. In these moments, and to the extent that we can widen these instances to allow us to experience longer periods of action free of the dictates of ego, we experience a process of disidentification with ego in which we know ourselves to be something other than the egoic identity that has been running us all of our lives.

In disidentification the ego loses, but only loses its stronghold over our actions. What we gain is the possibility for what might be the first moments of spontaneity that we have had in our lives, in spite of an idea about ourselves that we are "spontaneous" and "free" individuals. Or, we may actually experience a real feeling, even though we have imagined ourselves full of unique and real feelings all along, as through disidentification we become present to reality in a dynamic way.

We must humbly bear in mind, however, that for the vast majority of us mortals, disidentification will only happen in moments, and that complete and ongoing disidentification (referred to as "enlightenment" by many) is something to be claimed, if ever, only with the greatest care and humility. Instead, we will experience moments of disidentification in which clear-seeing is available to us, and we can use that vision to make choices that will inform and positively affect our lives when we once again—and usually very quickly—find ourselves laboring from within the confining chains of ego identification.

With disidentification as a wished-for possibility, the second task is to learn to live with ego, and even to befriend it or embrace it. The fact that we don't befriend ego was advertised by the slogan on a T-shirt that I was given, which read, "You need no enemies, you have yourself!" We must learn to "love thy enemy as thyself" because our true enemy is only ourselves, and we remain our own enemies until we learn to befriend the ego.

Although we are ordinarily identified with our ego—completely—we are also in continual battle with it. The soul is begging for release from personality's bondage, while ego stands armed, guarding every corner of the psyche. This battle rages (usually unconsciously) within us as we strive to live ordinary and happy lives, and yet there will be no lasting peace until we know ourselves and have accepted ourselves to the point of welcoming that which we perceive as the source of our very downfall.

In order to befriend ego we must turn directly toward those aspects of ourselves that are the greatest failures—the most wounded, decrepit, ugly aspects of ourselves—and internally pick them up in our arms and rock them back to wholeness, or even make metaphorical love to them until the life-force within them returns. "Perhaps all the dragons in our lives are just princes who are waiting to see us act, just once, with beauty and courage. Perhaps everything terrible is, in its deepest sense, something helpless that needs our love," wrote Rainer Maria Rilke. His words reveal with precision the process of what it requires to take our failures and transform them into our greatest assets.

It is not easy to walk into the mouth of the dragon and sunbathe in its fire, which is what the process of befriending the ego is likely to feel like initially! At first we must approach ourselves with the smallest willingness to see

something we have never wanted to see about ourselves, and intend wholeheartedly to tolerate this vision for as many moments as we are able to without turning away from it in horror or by seeking out some internal or external distraction from it. Only by proceeding in this way over as long a time as it takes—months, decades, lifetimes—do we then begin to more easefully allow those aspects of ourselves to coexist with our egoically-based self-image.

Down the road from coexistence with ego comes the beginnings of acceptance, and eventually a friendship develops. Befriending ego is like learning to live with and even love the roommate or sibling you swore you would hate forever. Time and shared experience creates tolerance and then love, which if we're lucky even turns to liking. Time spent seeing ego clearly, then learning to cohabitate with our vision of it, and finally accepting it even to the point of being able to laugh at our own horrors, eventually allows us to befriend our internal enemy.

The secret benefit of befriending the ego—which is yet another failure of ego turned successful—is that in so doing we befriend all egos. What we think of as our own personal ego is actually The Ego—the same ego that exists within and without all living entities, beginning with human beings and extending into states, cultures, countries. The Ego takes on specific character traits depending upon the individual or the culture in which it finds itself, but it is the *exact* same mechanism and operates the same way in all things. The only difference is one of flavor or mood.

Therefore, when we befriend our own ego—which is just a technical and fancy way to say that we come to deep peace and acceptance within ourselves—that process automatically extends to the rest of humanity. We cease to resist

and resent others for character traits that are mechanical in origin. We understand how human beings work, and through our struggles in undermining ego's dominance over us we understand how difficult it is for others to act differently in a moment, much less make any genuine and lasting change. Thus, our tolerance and acceptance of others expands in proportion to the degree of our own self-tolerance and self-acceptance.

When we begin to glimpse the magnitude of ego, it necessarily becomes more difficult to trust ourselves. Though ego has its unquestionable benefits, we learn that it can and will continually lie to us. It will feed us information designed to keep us in perpetual "endarkenment," and will do everything in its power to keep us as far away from Truth or God as it can. Therefore, in learning to know the ego we also learn to question ourselves and doubt ourselves in a way that we may never have done before. We become suspect of our own motivations and watchful of the countless ways we attempt to manipulate life from the moment we wake up in the morning until the instant we fall asleep at night and even in our dreams.

All the while, the failure of ego in this way and the seemingly disillusioning process of discovering our own falsity and untrustworthiness opens up the possibility for a deeper kind of trust. We cannot trust ourselves and yet we cannot afford to *not* trust ourselves, thus we search with interest and with a strong intention for what is ultimately reliable and truly trustworthy. "Intuition" is what some people call this deeper trust, yet even what we imagine our intuition to be may just be ego in drag. Still, our efforts

toward being truly trustworthy grow an increased capacity for clarity and discrimination within us. Paradoxically, an integrity of being arises when we know that we are likely deluding ourselves in every moment. Really! Our wisdom begins to stem from our knowledge of our own foolishness instead of a feigned sense of knowing, and we thereby learn to make choices and take responsibility for them, while at the same time becoming less righteous in our convictions and more respectful of the mysterious and unpredictable nature of life.

We cease to trust ourselves, and thus we are forced to trust God, the Universe, or Reality. We trust that our present experience is what it is, and that even if our experience of *what is* is deluded and informed by ego, then *that is what is*. Our ego has failed us and yet we are left standing as ourselves as we are situated in the moment. Thus we come to a more honest and humble relationship with life.

When ego is in control, we believe ourselves to be separate from God. This is the apparent great tragedy of ego. Here we are, human beings who are essentially indivisible from the Whole which we call God or Truth and therefore with no need to resist or fight anything because even death as we know it does not exist, and yet we spend our whole lives consumed in dramas and suffering based on a singular false belief. From one angle, ego appears to be a very mean trick played out on humanity by an unkind God. And yet without the presence of ego, we could not *know* that we are one and the same as God or Truth, for it takes something outside of God or Truth to be able to witness It. Jewish myth tells the story of how God got so bored after he finished cre-

ating the universe that he wanted to play hide-and-seek in order to have the experience of finding himself. Yet, he was God, so he could not think of anywhere clever enough to hide himself. He asked all the angels and none could come up with an adequate hiding place. Finally he asked the jester, who suggested he hide himself inside of human beings! Thus we have the present human predicament.

Cruel, kind, or neutral, the fact of our immersion in a lie which we can hardly see outside of *is* the fact of our lives, and thus we are faced with the task of finding our real Selves from within the mire of false vision. And, if we have glimpsed enough mystery to respect that there is an inherent intelligence in the universe that is worth knowing, we proceed in this very real game with a sense of spacious and humorous seriousness, as there is definitely a task at hand that we will be called to undertake sooner or later.

Still another angle by which to view the success of the failure of ego is through the consideration of a concept that Western spiritual teacher Lee Lozowick calls *enlightened duality*. Ordinarily the dichotomy between "enlightenment" and "duality" is viewed as irreconcilable: enlightenment is the realization of nonduality, and duality is the expression of illusion. Yet, in enlightened duality we take our vision of nonduality (should we ever be so lucky as to abide in it for more than a moment at a time) and, instead of dwelling in the bliss of union and oneness, we return our attention to the domain of duality, which is where the whole of our lives takes place, and is also the human arena that is desperately in need of attention and healing. We then attempt to live that duality—the realm of ordinariness, of relationship, and

of things—from an enlightened perspective and infuse it with the clarity of objective nondual reality. When this meeting happens, our realization does not separate us from our full humanity in any way, and on the contrary opens up far greater possibilities for our "enlightenment."

Ultimately, ego has the potential to become a tool of God or Truth itself. This is a very *big idea* but also a very real possibility. Ego will remain with us throughout our lifetimes, and we want and need it to do so because it will ultimately serve not only our own transformational process, but can become an extremely effective vehicle for serving others after its own essential transformational process of disidentification has occurred. When the individual turns his or her ego over to the service of Truth or God itself, then the very ego becomes a useful tool for that Truth or that God. In accordance with and manifest as our own awareness, God uses our own quirks, neuroses, and lovely and ugly personality traits—which are now fully conscious to us—as a tool both to help others undermine their own egoic identification and to provide an example to humanity of a living human being who operates free of the confines of egoic identification. We have befriended our ego to the extent that it does not own us; instead, we own it. We then use our ego via the vehicle of our personality as a constructive means for bringing us closer to our humanity and for serving the humanity of others.

"Failure is one of the simplest ways to destroy the ego."

—Anonymous

CHAPTER 10

THE FAILURE OF MEANING

AS HUMAN BEINGS we find ourselves in a strange and precarious situation. While we busy our lives with interesting and uninteresting activities and reassure ourselves that things are going along all right, at the same time we do not know with any certainty what is going on, why we are here, where we came from, and where we are going. Philosophies and religions do their damnedest to explain the predicament we find ourselves in, and we do our best to find faith and solace in their teachings, but the fact remains that there is far more that we don't know than we do know. We are faced with an existential quandary: we exist and yet we are not certain for what reason or what to do with and about that fact.

From this uncertainty springs a desire to find meaning. Because it is intolerable to even consider the fact that we exist just because we do, and that whether or not there is any ultimate meaning may never be known to us, many people never stop to consider these questions even once in their lives, although it is precisely this consideration that might paradoxically allow real meaning into our lives. Instead, we push the terrifying vulnerability of this situation as far back into our unconscious as we are able to, and

mobilize ourselves full-force into the task of creating meaning. Human beings are meaning-making machines. This is what human beings do. As living organisms of all shapes, sizes and colors, complete with highly complex mental-emotional apparati, we run around making up meanings, superimposing them on all the various situations we come across, and then believe those meanings as if they were as true as the existence of the thing itself.

Human beings are obsessed with their search for meaning because one of the things they are most afraid of is that there may *not* be any meaning. What if instead of Descartes', "I think, therefore I am," the reality was closer to the Zen master's, "I think, therefore NOTHING"? Or, what if even "therefore" never entered into the equation? We believe that if there was no meaning we would die, or that at least we would want to kill ourselves.

The first time I discovered meaninglessness occurred when as a young woman I was in an intimate relationship with a highly intelligent philosopher whose religion was meaninglessness. When in a moment I finally grasped what he had been prodding me to understand, I was devastated. All the horrors about life that we keep hidden in the recesses of our mind flooded my waking reality. I understood those people who spike their hair, mutilate their flesh, and display the inner chains of their mind on their bodies. Or people who commit unspeakable crimes in the name of meaninglessness, or those who are so overwhelmed by reality that they allow themselves to go crazy and seek asylum in mental institutions. The insight of meaninglessness was so ghastly that I not only wanted to literally bury myself alive in the earth, but I believed that as a result of my new understanding that I would never again be able to find love and appreciation in life. And yet, even in those moments, I

knew all too well that killing myself (or someone else, as more extreme people do) would do nothing to take care of meaninglessness. Thank God that wore off!

My initial insight into meaninglessness may have been more severe than that of many, but it both reveals and reminds us of the depth of darkness and fear that exists in all of our minds, whether we are aware of it or not. Thus we can better appreciate the measures that we understandably go to in order to avoid having such experiences.

Most of us are essentially grateful to be alive, and yet are understandably afraid that we may not fulfill the potential of our aliveness. We fear that there is a great boat that we might miss because we don't even know where to find the dock, and that even if we make it on board we might be asked to steer it and we are not a sailor, or that if it capsizes we might drown. Fearful as we are, we are faced with the fact of our lives and the certain awareness that nobody is going to do it for us, although Divine Help may conceivably be invisibly supporting our existence. It is not an easy situation.

Even people who do not know they are looking for meaning are looking for meaning; only the less aware we are of the fact of our search, the more unconscious and insensitive we will be to the outcome of it. The way this unconscious wish for meaning usually expresses itself is through our desires and wants and all the kind and unkind things we do to try to get what we want. For example, we may imagine we will find meaning in success, for that would prove (to whom?) that we are capable, useful, valuable. Or we search for meaning in knowledge, for the conviction that we know something gives us a certain feeling of power. Or we search for meaning through sex because maybe there we have tasted a little bit of some-

thing that whispers to us of God. We even search for meaning through alcohol and drugs, for among their many deadening effects they also create a flexibility in our perception suggesting to the unconscious that things may not be as stagnant and meaningless as they appear. People search for meaning everywhere: books, possessions, hobbies, food, knowledge, travel. In our passionate search for meaning, everything that exists within the manifest and unmanifest world calls out to us as the possible secret cache of that hidden significance that might suddenly and unexpectedly reveal itself, even though we may have looked in that same place thousands of times before.

The most common place people look for meaning is in love, for of all existing possibilities love holds the greatest potential for the actual existence of meaning. People intuit the possibility for a very real and objective love and they crave this experience. Yet, they simultaneously sense that such a love may also be painful, raw and vulnerable, and even require a price for its fulfillment so high that they might not be able to pay for it without significant efforts. Consequently, they more often settle for a partial love or half-love as a less expensive substitute, which unfortunately will never deliver the desired goods.

We first look for love through our partners and our children, yet because this love is so challenging we quickly find ourselves confusing and exchanging love for need, vulnerability for comfort, raw exposure for codependence. Whereas Love always exists—irrespective of the physical presence of those whom we love—it must be continually opened to again and again and again. It cannot be owned,

pinned down, captured, or bought on an insurance plan. Need and dependency, on the other hand, can be easily agreed upon in the invisible contracts we sign amongst ourselves. These agreements come in endless forms. With our lovers our contract may read, "I'll give you comfort and financial support if you give me the reassurance that I am special to you," or, "I won't leave you if you won't leave me." With our children our contract might say, "I'll take care of all your survival needs if you pretend to be okay with the fact that I cannot tend to your emotional needs," or, less neurotically, "I'll love you because your existence allows me to feel needed and thus valuable in this life." We want meaning, and in our unconscious fear of vulnerability we take what we can get as cheaply as we can get it, though often we end up settling for far less than our capacity.

Unfortunately, as discussed in the failure of love, partial love and codependent love cannot satisfy that within us which is looking for real meaning. Thus we either give up on the ones we thought we loved because they are not providing us with what we think they should give us, or we even give up on the possible meaning in love itself, convincing ourselves that it is only something we read about in a novel.

Sometimes we try to make meaning where there is none. Or, we are uncertain as to whether or not there is meaning and, instead of resting in the discomfort of incertitude, we improvise a meaning. "My husband hasn't told me he loved me in three days so that must mean he is having doubts about the relationship." Or, "I saw three doves pass over my house and that means it is a good time to try to get pregnant." We are insisting upon a meaning that may or

may not be there, or one simply may have not revealed itself, and so we use fantasy—either positive or negative—to distract ourselves from uncertainty.

The result of premature meaning-making often expresses either in paranoid thinking or magical thinking, depending upon the tendencies of our personality. If we are paranoid we may think, "I scored low on the college exam so that must mean I am essentially stupid and unfit for higher education." If we are prone to magical thinking we might say, "I scored low on the exam because my real destiny is to be a movie star and this is just the sign from the universe to proceed in that direction." We grasp at signs in order to complete our self-fulfilling prophecy, not realizing that it is our unconscious mental tendencies that bias our acceptance of one possible meaning over another.

We also see this premature meaning-making phenomenon going on when we are doing something just because we want to, or even as an indulgence, but instead of being willing to take responsibility for this we create some special meaning. "I am having this affair with a married man because I need to connect with different aspects of my inner masculine." Or, "I had a dream of crystal blue waters with eagles flying above it and I know it is a sign I should go on a retreat to Hawaii." Or, on a grosser level, "I am yelling at my child because she needs to learn who is the boss."

I hate to say this, because I implicate myself in this accusation, but psychologists and zealous spiritual practitioners are often most guilty of the phenomenon of meaning-making. Because they are identified with occupations that are laden with possible meaning, and in fact their income or their spiritual stature is often dependent upon it, they use their clever minds or spiritual sensibilities to skillfully craft highly intelligent and plausible meanings for

things. Their cleverness becomes their detriment in this instance because they are unlikely to catch themselves red-handed, and for others to dare to undermine them they must be as equally witty and inventive as these sharp and all-too-spiritual meaning-makers.

When we try to make meaning where there is none, we will fail because we will make false meaning. False meaning is much worse than no meaning because then we are stuck in the land of self-deceit, having lied to ourselves without knowing it and even under the fancy guise of self-importance. Furthermore, we become so convinced of our false meaning that we become blind to any actual meaning that may exist in the situation.

One of the great Buddhist teachings related to the failure of meaning has to do with the understanding of emptiness. "Form is emptiness," says the scripture. If we look carefully into the nature of existence, there is a quality of space and nonexistence at the base of all things. With diligent efforts, we can actually experience the fact that the universe is a creation of our minds, of consciousness, and is as unreal as it is real (the realness and fullness of it will be discussed shortly, but for now we will pursue our discussion of emptiness). From our vision of emptiness, we see things as neutral, essentially devoid of any actual substance. This can be a powerful insight in the course of one's life. Whereas meaninglessness tends to carry with it a value judgment of negativity, emptiness simply expresses a reality that is true of human experience.

Yet, after the experience of this powerful insight, what do we then do with it? At best, we allow it to pass as it is

wont to do, and we remember it as a reference and watch for its possible implications in our daily lives. Or, if in our insight we see that there is something practical we need to adjust in our lives (*not* drop out of college and become a monk because we think we're enlightened, but something more reasonable), we use our new vision as the incentive to make a necessary change. But as meaning-makers, human beings are often unable to hold the insight into emptiness lightly and in a balanced fashion.

The insight into emptiness and meaninglessness is often, in my opinion, one of the most misused commodities in the spiritual marketplace. Many popular spiritual paths deliver the teaching of emptiness, and even the accompanying technology that allows us to experience it. However, we are often made privy to this technology before we have developed a proper internal matrix or foundation to understand it. Therefore, ego easily co-opts our insight and we start to think, "If everything is essentially empty, it doesn't matter what I do because everything is the same—so let's party!" Or we say, "Now I have realized that everything is empty so there is no further insight to pursue. For what can be deeper than nothingness?" In so doing, we stop our spiritual development, or at least delay it, in its tracks. Of course it is natural that our initial insight into emptiness will fill us with thoughts and ideas of our great spiritual prowess and grandiosity (yet another meaning!), but if we are serious about continued development, we will have to let these go in favor of the next step on the path of failure.

There was a time in my own life when I understood this idea of emptiness in an entirely new way. Sure, I had

been through the initial insight into meaninglessness as a teenager, the emptiness insights while experimenting with illicit substances, the existential discovery of insignificance with my philosopher friend. Years of meditation had proved these to me time and time again, and I had even written books describing them, but I remained unprepared for the starkness of the understanding that my life as it is right now (whenever "right now" happens to be) is all there is.

Suddenly my whole life sobered up. I wasn't on the spiritual path to *become* anyone. I wasn't doing the hours of daily disciplines in order to get something. My work as a writer wasn't going to lead to something objectively solid or substantial. My efforts at intentional and conscious relationships with people weren't *for* anything. My attempts at service weren't going to bring me any rewards. "Your efforts will go unheeded in both this world and the next one," writes teacher and consciousness pioneer E.J. Gold. Frankly, I was horrified by the fact that my present experience—full of its joy, depression, efforts, laziness, successes and all—was all that there was to life. Sure I might grow into a fuller humanness over time, but that would be then, and my experience of myself then would still only be what it was then. I was (and still am) stuck with myself in the moment of life in which I found myself, and I almost couldn't bear it.

"Be here now" is a tricky predicament. As Ram Dass, the author of the book by the same name promised us, this is ultimately true and inarguable. Yet most of us aren't here now, as Ram Dass would also be the first to admit! Right now we are somewhere else—in some fantasy, in the past, in the future, lost in a fear or drifting in a faraway emotion. If we are able to actually be with ourselves in that fantasy or fear and know we are there, we are not lost, but oftentimes we are simply in exile from ourselves. Of course there are

qualities and shades of being here now, because we can't really be anywhere else. But until the time of my own deeper insight into this truth, I had not been willing to face my experience with enough honesty and clarity to know that it did not exist for the purpose of becoming something else or to change into something more pleasant. "Being here now" should be effortless, and often is, yet paradoxically we cannot just assume that that is what we are actually doing. At the risk of over-efforting the effortless, we benefit from attempting to penetrate our present experience with greater awareness and presence.

Furthermore, although I was unconvinced of this at the time of my stark insight into emptiness, there does remain a certain humor in the situation. Here we all are in a profoundly mysterious universe in which we are unconsciously half-freaked out about our own death, running around creating invisible cardboard boxes of concepts, philosophies and projections, engaging dozens of failed relationships, and all the while infusing our experience with intense meaning and significance . . . and believing ourselves entirely! It is a devastating situation we find ourselves in, and yet in its aspect of meaninglessness it is quite funny. It is funny that we insist upon taking ourselves so seriously, that we must find meaning in order to believe we are worthy when we already have self-worth and all the integrity we need in the simple fact of our existence. Laughing at our own predicament can be the hardest thing in the world—particularly when it undermines the important significance we have placed upon ourselves—but it is one of the best-known antidotes to seriousness and addiction to meaning.

The point (or maybe even the meaning!) is that maybe everything doesn't have meaning and that some things are just what they are. "See that eagle it's just a bird, see that black cat ain't you heard, see them stars there ain't nothing else above . . . " sings rock band *liars, gods and beggars* in their song "No Hidden Meanings."

Arnaud Desjardins, the revered French spiritual teacher, talks about "accepting what is, as it is, in the moment." When anything happens either externally or internally—an expected or unexpected circumstance, emotion, relationship dynamic, anything—instead of rushing to interpret or analyze it, we simply acknowledge, "What is, is." Whatever is happening right now is what is happening, and in this way it doesn't matter whether or not it has meaning. In fact, even looking for a meaning that may or may not be there may be a distraction from the task of simple acceptance.

When we let go of the need to create meaning even when there is none, we are indeed faced with life as it is. And sometimes life "as it is" is just great and we are happy to accept it, but more often than not we have to accept lives full of imagined failures, and full of dreams that have been shattered and those that are still waiting to be shattered. We have to accept a life of loss as well as one of gain.

This acceptance of *what is* actually offers us the possibility of winning once again. "Accept your limitations and they are no longer yours," it is said. In the act of acceptance something unexpected can happen. What? Well, if we talk too much about what it is, then we'll just try to cheat and fake premature acceptance and then we won't accept it at all, so best for all of us that we just work on the acceptance!

Returning to Buddhism, whereas the insight of "form is emptiness" is proven by enquiry to be objectively real, "emptiness is form" is the other half of the equation that for some reason is rarely given proper airtime, even though it is written in the same scripture. If from within the realization that "form is emptiness" we look around ourselves, we cannot help but to see forms everywhere! Form is all there is as much as emptiness is all there is. Emptiness has manifested itself in the configuration of form, and thus to insist upon emptiness over form is to abide in only half-truth.

If we allow ourselves to experience form, and even appreciate it moreso for the miracle of its manifestation from emptiness, then we are faced with a new situation. We find ourselves in a potentially neutral or even meaningless world, but one that is simultaneously full of life and creative possibilities. It is at this point that we are best equipped to create meaning—*after* we have been willing to see and to accept meaninglessness. We can now choose to either consciously infuse form with qualities that resemble meaning, or even take our chances at tapping into something that may be meaningful beneath and outside of emptiness and meaninglessness. In terms of what we should apply significance to, I would personally go for one of two things: Love or Truth.

"Ain't no significance to anything but love," the song continues. We have all tasted love, and can even sense it in its absence, and most of us would agree it is not only the most real experience we know, but also the most gratifying one. It is the most popular subject of any song or poem every written, the favorite subject of mystics across the board, and the thing we are all looking for in every moment of our experience and in every corner of our world, even if our actions sometimes make it appear as though we are pushing it away. Love may or may not have any essential

meaning, but it is a gift to humanity, a precious possibility available to human experience. Therefore, if we want things to be meaningful or at least satisfying, we best aim at filling them with love. For even if our love is not real and we are just love-wannabes in training, Love itself is a force that is most generously and mysteriously willing to take our confused efforts and transform them into something that is filled with itself.

To find meaning in Truth is essentially the same thing as finding it in Love, but just as some people prefer chocolate ice cream over vanilla, some favor the flavor of Truth over that of Love. Again, if we really go for Truth we will not be left untouched or unchanged, because our intention toward Truth will keep us willing to have all the falsity in our lives revealed. Useless meanings will fall away in their own time, mystical and paranoid thinking will be revealed in its inconstancy, and we will be left with an increasingly pure and simplified, but complete existence. Unsentimental, unadorned and yet full, here we can find our satisfaction whether it means something or not!

If we make meaning while knowing we are making it, we get the best of both worlds. Our lives are motivated by something and moving toward it (as in the case of Love or Truth) and at the same time we are not overly convinced by our own creations nor do we take ourselves entirely seriously. We must simply stay away from the trap of finding too much meaning in the act of conscious meaning-making!

Beyond and outside of the consideration of meaning or no meaning, there remains a longing for meaning.

What if we were to discover that deep within that longing itself was a precious quality that may be more valuable and deeply satisfying than any available meaning? Maybe we would call that quality God, or we might just call it deep humanity, or maybe it is the Love spoken of above. If we allow our insight into the failure of meaning to undermine our longing for meaning, we lose something precious, for our longing for meaning may be a façade or a mask for that which we really long for. Thus, we benefit from letting some of the meaning go and allowing the longing to remain.

Having said all of this, there remains the possibility that there is profound and very real meaning in everything, only we cannot know it from within the confines of our own ego. From ego we can conceptualize meaning, or create that which is meaningful to ego and gives us relative or even deep satisfaction, but we should be careful not to presume that we know what that meaning is. Life is a risk. We cannot be certain of things in the way that meaning promises. We simply attempt to live with eyes open, make choices to the best of our abilities, observe the reactions and consequences, and see if we can learn something.

CHAPTER 11

THE FAILURE OF ENLIGHTENMENT

(To Be What We Imagined It to Be)

THERE I WAS on the airplane to Mexico City—an eighteen-year-old hippie traveler with an unquenchable spiritual thirst and not an ounce of discrimination. Fancying myself as Carlitas Castenada, and on my way to apprentice with an Aztec shaman, I distinctly remember thinking to myself, "If I stick with this diligently and study really hard, I'll probably be enlightened within two years." I hadn't a clue—and thank God—or I probably would have stepped off the spiritual path then and there. For the potential "success" contained within the failure of enlightenment would not be apparent to me for many years to come.

On almost every serious spiritual path there arrives a poignant moment of insight in which you can no longer avoid the realization that there is a significant likelihood that you will not actually get "enlightened" in this lifetime, whatever you imagine this so-called enlightenment to be. You must face the fact that your unique, special, and God-favored self does not in fact possess any particular advantage toward being chosen for the sought-after sacrament of enlightenment over and against the multitudes of comparably talented seekers who experience their equally intense longing as uniquely as you experience your own.

This moment of uninvited insight happened for me when I was living at an ashram in India. A friend of mine, upon seeing my obvious state of despair and spiritual disillusionment at the difficulty of the demands of spiritual life in that environment, approached me and said, "You really didn't know that you weren't special, did you? You didn't know that your odds weren't greater than anyone else's. You didn't realize that all the spiritual seekers around you were thinking the exact same thing as you—that they were *the one* who was going to make it." I blushed inwardly and tried to hide my embarrassment under some comment of feigned spiritual confidence.

Those of us who secretly believe ourselves to possess this spiritual advantage may not be willing to admit to it aloud, or perhaps even to ourselves. But, at the often unwelcome moment of realization that this enlightenment may not be ours to possess and that we might in fact be yet another spiritual failure, there simultaneously arises an unavoidable understanding that we had indeed thought ourselves more special, more "in" with God, more evolved. It is this insight that offers us real value and the possibility for a strange kind of "winning" on the spiritual path.

Andrew Cohen, a contemporary spiritual teacher, suggests that one of the main reasons that people think they want to be enlightened is not because of any essential desire for Truth or God, but because they feel profoundly inadequate within themselves. The potential for enlightenment becomes synonymous with the possibility that they might finally have the chance to be special—in fact, the most special of all: they get to be God himself or herself! Yet, from the perspective of God or Truth, nobody is special, and as all the truly great ones have said, you only become The One through the realization that you are No One. You only become special when

you know from inside out that you are not special. Thus enlightenment will always fail in its imagined promise to bring freedom from our ordinary and often pained existence.

Within contemporary New Age culture, enlightenment will fail because although we have no idea what it is, we presume to know exactly what we are talking about regarding all matters spiritual. Magazines casually talk about gurus and enlightened individuals, people talk about their "enlightened circle of friends," or highly questionable teachers talk about their dozens of enlightened students. The brand of enlightenment spoken about here usually refers either to some low-level psychological insight, a dramatic experience of white light and diamonds, or some individual who is moderately insightful in a world in which wisdom is increasingly becoming extinct. There are many perspectives emerging that are more awakened than that of the deadened consciousness so common to the Western world, but this is in no way synonymous with enlightenment.

Therefore, not only do we fail to be enlightened, but the term "enlightenment" itself also begins to fail, as its meaning becomes distorted and tainted. A culture that has become watered down in its capacity for a collectively refined ability to think clearly and produce wisdom and authentic humanness also dilutes the sanctity of spiritual matters in order to fit into its own limited capacity for understanding. The end result is a brand of pseudo-spirituality and pseudo-enlightenment that matches the general ability of the culture but lacks its original essential meaning.

The most problematic difficulty of the failure of enlightenment on the level of contemporary spiritual cul-

ture is that it is both deceiving and confusing to the earnest but naïve spiritual seeker. Attracted by some vague notion of "enlightenment," such an individual is more often than not exposed to a wide pool of misinformation regarding what it is and what it isn't, and is left to wade in the waters of false spirituality until by a stroke of luck that which is deeper becomes obvious.

Perhaps the primary reason enlightenment will fail is that it does not exist as a concrete, fixed thing—something that can be attained, guarded and controlled. "Enlightenment is the knowledge that all things are transitory, including enlightenment," said Lee Lozowick. Enlightenment is consistently slippery and evasive. Although there may be a point within the spectrum of spiritual life in which a certain distinct realization or recognition that could be called "enlightenment" takes place, this moment cannot be grasped or owned. For as all the scriptures tell us, enlightenment is always present anyway. It is our own transitory experience that slips in and out of abidance in that state.

Most people who claim to be enlightened fall on their faces. They have a great realization of God, or the oneness of things, or of the interrelatedness of all phenomena—a realization or at least the remnants of one that lasts for some time—and they assume this to mean they are enlightened. They wear their enlightenment as a banner and tout themselves as spiritual teachers as they go about a career of being "The One." I recently met such a man, and sat captivated as he told me about his struggles to convince other people that he was enlightened so that he could become a spiritual

teacher. He had noted that one of the popular contemporary teachers had spoken openly about his own enlightenment, so this man decided to follow the model and simply go around telling people that he was enlightened and was now a teacher. To his dismay, the response to his advertisement was unsupportive to the point that certain friends could no longer tolerate being around him. Instead of using their response to reconsider his own enlightenment, he automatically interpreted their feedback as their own resistance to moving through their blockages to enlightenment.

Similarly, I was recently at a spiritual event speaking with a man in his fifties—a self-proclaimed veteran of the spiritual path—about how presumptuous people tend to be in their pretentiousness about being enlightened. "Not me," he said. "I often think that I actually *am* enlightened but pretending *not* to be." Case in point. This man was the object lesson itself.

The teachings of nonduality tell us that on one level we are all already enlightened: that there is nowhere to go and nothing to do and that all that exists is the present moment and we're all one and there's only God and, and, and But is there not a certain element of spiritual gobbledygook in this thinking? The fact that all of this is true never stopped murders, child abuse, daily enactments of manipulation, power-tripping, and needless suffering. In fact, those ideas alone have rarely even made somebody a better person, much less the living embodiment of the divine, and have certainly provided the justification for more than a few spiritual scandals, abuses and messianic dramas.

Whereas spiritual truisms are fine ideas and useful to study in terms of enlarging our vision of possibility and providing us with inspiration, the repetition of fancy spiritual *dharma* has in no way succeeded in making enlightenment

a success. More often than not truisms lend themselves to an even greater failure of enlightenment, as we easily become fooled into thinking that just because we can enunciate the *dharma*, that this means we can also fly. People spend decades and even lifetimes waving banners of imagined enlightenment, when all the while the failure of their actual enlightenment only deepens.

Enlightenment will further fail because it was never meant for the masses. That which is referred to as "the pearl beyond price" cannot be bought at K-Mart or at a weekend workshop. That which is sacred and precious is also rare and very expensive, in this case the currency being that of unimaginable efforts, dedication, devotion, and a depth of sacrifice largely inconceivable to humankind.

Yet, Western consumer culture, in its belief in its own superiority and ability to buy even spirituality with hard cash, consistently argues that enlightenment should be cheap and available; mass-marketed; made in Asia by yogis who work for low wages, and resold in the West for no more than a pretty penny. "Enlightenment" *is* sold by Asians and Westerners alike who don a fancy turban or sari, take on an Indian name and a radiant glow, and for a high price reproduce and repeat sacred language. Nowadays, counterfeit spirituality can be found at the corner store. But, as has been and always will be the case, the most precious jewels remain buried in the mines of the soul and will only be discovered by those willing to expose themselves to the potential hazards, mudslides, and plain old dirty work of genuine spiritual transformation.

A useful question becomes, "How can we accept the inevitable failure of our own enlightenment without falling into the trap of spiritual passivity?"

As we have discussed previously, there are those individuals who say, "We are all already enlightened, so what does it matter what I do anyway?" and who use this as an excuse to indulge in excesses of immoral and unconscious behavior that is often hurtful to others. "For in nonduality," they say, "there is no right and wrong." This approach assumes that we actually understand what enlightenment is, and that all the intellectual insights we have had, and even actual experiences, mean that we really know what we are talking about in a consistent way.

On the flip side are those who say, "I am never going to get there anyway. The odds are about one in ten million, so why bother?" They have had a vision, or even many, of tremendous possibility, but they have also glimpsed what is required to fulfill that vision. Their lives may exhibit excessive indulgence, or perhaps are disciplined and well contained but nonetheless reveal an element of unaccepted despair.

A more "evolved" school of contemporary thinking advocates living our enlightenment in the context of ordinary life, and states that this so-called enlightenment is in fact no different than life itself lived consciously. Many of the people who support this viewpoint are those who have realized through years of experience that spiritual life is simply not what we thought it was, and that the whole process of "seeking" instead of acknowledging what is already here is the very thing that keeps us from resting in wakefulness in the present moment.

Whereas this perspective is highly functional, it is once again laden with the temptation to use failure as an excuse instead of as an empowerment. "Enlightenment is found in ordinary life," they say, but in so doing may relieve themselves of the demand to live this ordinariness with those qualities of impeccability, effort, and "enlightenment" that make it extraordinary. As Lee Lozowick said, "When ordinary things become extraordinary, and extraordinary things become ordinary, then enlightenment has been glimpsed." Therefore, if ordinariness becomes an excuse to forfeit our extraordinariness, even under the evolved guise of spiritual maturity, we have forfeited a valuable spiritual possibility for ourselves.

When we realize that our spiritual prowess is not what we had imagined it to be, it is easy to fall into despair. "Why spend my whole life struggling toward something that I am likely to never discover," we may ask, "when I could just live the high life instead?" This is a good question, and there are a lot of possible answers to it, none of which we can ever be certain about.

The first and perhaps most important response to this question is that there exists a spectrum of spiritual development upon which enlightenment is only one mere point, and wherein there is literally no end. If our whole lives are about attaining one imagined thing called "enlightenment," we are likely to stop our development when we reach that state, thus stunting the possibility for unimagined heights and depths of human growth.

Second, perhaps the path itself that claims to lead to the imagined enlightenment is the end as well as the means. "The path is the goal," taught Tibetan master Chögyam Trungpa Rinpoche. The possibility for real human fulfillment may exist within the struggle for something we will more than

likely never succeed in getting. If this is the case, then the efforts we make must in and of themselves be the reward. We must find a certain satisfaction both in the attempts we make to succeed and in the inevitability of our defeat. We all know that human beings are imperfect and will continually make mistakes and exhibit their imperfections, and at the same time we are called to strive for something that we are destined to fail at, the task perhaps being that of coming to terms with our winnings and losings in order to deepen our understanding of our own humanity.

Furthermore, it is conceivable that the sacrifices we make for the spiritual path actually feed the path. That in the moment of the act of sacrificing one thing for something else (as opposed to pointless masochism), we are remembering and placing as a priority that which is most important to us—whether or not we can name and define that priority with precision.

Perhaps the real enlightened life is meant not for ourselves but to serve all of humanity. Humanity needs help, and perhaps even God does too. The efforts and countless inevitable failures on our path to enlightenment slowly wear down our selfishness, arrogance, vanity, self-importance, and gradually increase our possibility to serve humanity. Instead of clinging to the pride and self-protection of our own spiritual attainment, we become willing to fail and to open to those failures because we know that it is the wearing down and not the building up that leaves us whole and real and able to contribute something useful to life.

As is the case with conscious failure in all domains of life, the failure of enlightenment represents the greatest

possibility we have to engage in a truly enlightened life. When we fully recognize and accept the fact that in spite of our own relative extraordinariness in this domain or that one, we are in no way essentially special, exceptional or privileged in the eyes of Truth itself, there opens the possibility for a life lived with eyes open to the humility of both our light and our darkness.

If we are wholly committed to the process of transformation or spiritual growth (which we may or may not be, and neither is "right" or "wrong"), then our failure to become enlightened, and even the failure of what we imagined enlightenment itself to be, will once again only be the failure of some tightly-held idea or concept as opposed to the non-success of the thing itself. Shedding these false ideals reveals that which is beneath, essential and real. In this way we sacrifice so-called enlightenment for the sake of a greater possibility of an unnamed and undefined yet very real possibility.

CHAPTER 12

THE FAILURE OF GOD

(TO BE WHAT WE BELIEVED HIM, HER, OR IT TO BE)

EVERYBODY WHO HAS BEEN disillusioned by the Easter Bunny or Santa Claus knows the experience of the initial failure of an imagined god. As a young Jewish child, I took pride in my secret knowledge that the neighborhood's Santa Claus was actually skinny Mr. Ryan down the street dressed in a costume. Nonetheless, for a long time I still thought there was a beautiful man with a long white beard who lived in the sky and who loved me. And I still believed there was a beautiful land called heaven, until I asked my parents what happened when you died and my father told me that you go to paradise and my mother told me you dissolve into nothingness. The discrepancy in their responses revealed their own uncertainty and thus undermined my own confidence in God.

Children who have been abused, or lost a parent at a young age, or been shamed for a behavior that was an expression of their innocence, have experienced the failure of God. Adults who have contracted a fatal disease or been faced with an unexpected or severe accident know God's failure. Most of us who have ever experienced real heartbreak have touched the failure of God. In fact, it could be

said that everyone alive has experienced, or will experience, the failure of God as we imagined Him to be.

I will say up front that although God may well be a Him, Her, It, They, Us, or none of the above, the hassle of having to be spiritually-politically correct by writing out each of these possibilities every time is simply too great an inconvenience for the purposes of this discussion; thus, perhaps to the reader's dismay, God will be a "He" in this chapter, and it will not *mean* anything (see Chapter 10: "The Failure of Meaning"!).

The images of God we are ordinarily raised with in popular culture not only reflect a profound lack in our collective knowledge of that which is Spirit, but also do a great disservice toward thwarting our potential to wake up to the extraordinary possibility of what God might really be. Along with most of my Jewish and Christian friends who were indoctrinated with the notion of a punishing God, I never trusted the God I was raised to believe in, and with good reason. "GOD IS TO BE FEARED," I was taught. "You show your respect of God by fearing Him."

Most children are taught that if they obey the rules set out by their priest's or rabbi's interpretation of the New or Old Testament, combined with the largely subjective and neurotic mandates dictated by their typically neurotic (though well-meaning) parents, God will smile upon them and give them lots of nice clothes, yummy food, cool toys, fun vacations, and most importantly their parents' love. If they break the rules, they are *bad*, and their badness will not go unnoticed in heaven or on earth. If as adults we are unable to mature in our relationship to God, these dynamics remain, although they have donned a more sophisticated disguise. For example, we may adhere to a strict moral or ethical code that is so rigid as to be inflexible, and accord-

ing to which we fill with shame and terror when we fail at fulfilling its requirements. Or, as I have seen with many clients, we may get ulcers because we are ashamed of our "dirty" or "bad" thoughts, and bring upon ourselves endless and needless suffering because the limited notions of God that we carry within us leave us no mental breathing room. We suffer our ideas of God, while God patiently waits until we can get over ourselves and our early conditioning.

In this way, we can easily see that it is not God Himself who fails, but instead it is our imagination of God that fails us—an imagination and idea of God that was taught to us by our religions, cultures and parents, and perpetuated and reaffirmed by the internal psychological patterns that resulted from those mental engravings.

It is a radical insight for most of us when we realize that although the biblical stories may have actually happened in some form or another, that they also exist as a metaphor for the human psyche and as a map for human transformation. The great religious myths of all the great traditions were specifically designed in order to be taught and understood on multiple levels so that no matter the depth of someone's intellectual and spiritual capacity, he or she would be able to receive the teachings at that level, while receiving an unconscious hint of what might await them at the next layer.

Whereas religion as a metaphor for the psyche may seem obvious, it is quite shocking that many, if not most, of the religious leaders in the West who teach these ideas do not know this simple truth! In fact, recently I was reading some books about the Jewish holiday of Passover to a

group of young home-schoolers, when they began to question me as to whether the stories were real or symbolic. I had to explain to them that they were partially true as well as being a metaphor for the internal process of purification (a concept that these extraordinary young children were able to grasp with amazing ease!), but that unfortunately even the authors of the books themselves did not acknowledge this fact.

In this way, we might consider that even the God that is referred to by the renowned religions and the great scriptures is Himself not prone to fail us in any way. Instead, it is the interpreters of those religions and texts who have left us with confusing and limited ideas of who He is, how He functions, and the largess of His mercy and the room He holds for us to "fail" in our humanness.

Even when we have outgrown our culturally and religiously ingrained images of God, we can still become easily and painfully disillusioned by Him. I know more than a few people who have gotten angry and even violently pissed off at God, and I think it is a healthy thing. If we remain ever insistent upon trying to be sweet and nice and charitable and an overall "good citizen" for the sake of God, not only will we live out an extremely anal and unnecessarily limited existence, but our repression is bound to show up in one form or another—whether that be constipation or passively-aggressive behavior toward our spouse.

In addition, God appears to act in some very nasty, if not simply confusing, ways. He throws curve balls constantly, takes carom shots at a whim, or sometimes just walks right up to us and punches us smack in the face. He steals away

our lover to another woman, or kills our child in a car accident, or burns our home up in a fire, or gives us cancer, or gives us a bad life . . . or even just a really bad hair day. God often seems to totally disregard our pleas, our desires and our dreams. What kind of God is that?! Certainty not one who *appears* to give a shit about our humanity.

It is well to curse God, for there is probably not a truly admirable human being on this planet who at one point or another has not done so. There is no reason we should not at some time or at many times be obscenely frustrated and insulted for the raw deal that God has given us. We should condemn God with obscene blasphemies and give Him the finger and swear our hatred, and cry for our mommy to come save us.

And then, when our temper tantrum has passed, we can quiet ourselves and move deep within to the sobriety of the reality that lies beneath our disillusionment. There we begin to contemplate, to question, to dig within ourselves for answers that cannot be found in the often ugly appearance of things. We recall, in spite of ourselves, the gift of our lives, and in so doing allow the sorrow of our questions to penetrate beneath our feelings of abandonment. From precisely this point arise the beginnings of knowledge that can only come when we have allowed ourselves to feel the burn of the betrayal of our God. "God will abandon you," I was once told when interviewing a great spiritual master. "Yet He will do so only so that you may know Him still more deeply."

God will fail us when we expect Him to take responsibility and blame for those things that we as human beings are fully responsible for. "Render unto Caesar what is Caesar's

and to God what is God's," Jesus said. We fall into a great trap of false perception, and cheat ourselves most of all, when we make choices that screw up our lives and then demand that God be responsible for the consequences. Not only will God unsentimentally refuse to do so, but if we do not understand the distinction between what is our responsibility and what is God's, then we will mistake God for being uncaring when in fact it is God's love that allows us the full right to both our own actions and our own consequences.

It is fine to make all the errors that we wish to, or use our lives and bodies as laboratories in which to conduct certain experiments about life. We are given that option and we can and should use it, but when the results of the lab tests do not turn out as we desired, do we blame the laboratory itself, or do we allow ourselves as the chemists to take responsibility?

There exists such a thing as free will, which can be viewed either as the gift or curse of our humanity, but is ultimately nothing but an extremely generous offering. Free will is an issue obviously too large to do justice to here, but it is nonetheless worthwhile to overview this perplexing consideration. Although on the widest and most objective level of existence we could say that God is ultimately accountable for everything, yet within the laws of subjective duality, which is where we live, there are concrete domains of accountability. In certain arenas, God or Truth or Reality is the only force that can and will dictate events and outcomes; in other domains, we as human beings must assume full responsibility; still other terrain is full of gray areas. Did we get stomach cancer because it was our destiny, or because we ate too much and the wrong things, or from genetic patterning? Even if God is ultimately responsible for our child's well-being, we can never excuse ourselves for

selfish or neglectful parenting, and even if God is ultimately responsible for our transformation, we must proceed with our efforts in such a way that even God Himself would be impressed with us.

The issue of free will is clearly paradoxical. We must take full responsibility for our free will, for the laws of action and consequence, and certainly for our own choices—ceasing to relegate them to a God who could care less whether we eat meat or not, or whether we go to church on Sunday morning or Wednesday night, or whether we drive over the speed limit. God as Savior will not save us from guilt, from psychological conflicts, from stresses at work, or from our abusive husband. Yet, at the same time, our free will exists in the context of a greater God, or Truth, and we can remember and respect that, and even take refuge in the fact that there is a larger intelligence that wishes to take us to its shore if we are willing to learn to steer the boat. "If you take one step towards God, then God takes one hundred steps towards you," it is said. We *must* take the one step that is ours with the presence and attention that we would give it if there was only ever one step to take.

When we have ceased to indulge our self-pity, it is understandable that at times we will become disheartened in the face of God, particularly when we are face-to-face with not only our own suffering, but with that of humanity. When walking through the exquisite but blood-stained park outside of San Salvador, El Salvador, that just months before had been the sacrificial grounds of thousands of men, women and children, I certainly wondered who the God was that had allowed that to happen. At that moment, all

the karmic explanations and spiritual rationales I had used and heard used to explain such wars and injustices sounded to me like mindless gibberish that was dreamed up to paint a façade over something that could not be reconciled by the human mind. From what I could see, God seemed to have failed in this instance.

At the same time, we must respect that there are an infinite number of forces at work in the universe that we do not, and may never, fully understand. Karma, for one, is a very real dynamic. There is an unchanging consciousness that exists at the base of all manifestation, and that consciousness does manifest in living forms based on the laws of cause and effect and action and reaction. Whereas New Age ideology often over-personalizes the principle of karma, claiming that "we" create everything good and bad in our lives through our own greater or lesser degrees of enlightenment, the fact remains that all of our experience over all of our lifetimes (whether or not we believe in more than one lifetime) is connected.

There are also lawful relationships among all things on the earth and in the universe that must be respected. God will usually not interfere with these, and it is not because of His own failure but because human beings need to work out their own evolution with diligence. There are degrees of knowledge and understanding and resolve that we must earn through our own efforts, and for which too much of a loan from God would not serve us in the long run.

In addition, there exists in life a denying force as well as an affirming force. God never claimed to be wholly benevolent, and the fact remains that there are forces that are working against our own liberation or fulfillment while others are simultaneously working towards it. Instead of lamenting whether or not God has failed us because these

forces exist, it is more useful to come to know the situation for what it is so that we can learn to navigate wisely through the obstacles we are sure to meet with on our path toward greater wholeness.

Furthermore, our humanity is a mystery which, if at all possible, can only be understood by resting in a context of understanding so radical and rare that most of us will never have the privilege to abide in it this lifetime. Yet, our lack of understanding does not preclude the existence of a kind of perfection that does exist in spite of the seeming horrors apparent within it. God has not failed us, but we have failed to understand God, and in so doing we will at times feel forsaken by a force that is really working in the service of our salvation.

Lastly, in spite of our disillusionment with God, I have found that in the final analysis everybody is still looking for Him. The great Persian poet Hafiz tells us that there is "nobody on this earth who is not looking for God." In spite of our sorrows, something within us can simply not deny the wonder of the mystery, the seeming impossibility of our very existence, the unfathomable existence of the cosmos. When push comes to shove—usually at the approach of death, as we will see in the next chapter—not only our fears about and skepticism of God emerge, but also our profound inner knowledge of That which we had imagined to be unknowable.

God doesn't live in the sky, and it seems that we are nearing a time in the development of humanity and religion where this should become increasingly obvious to the masses. If God exists in the sky, then the earth must

be home for the Devil, and as we can see, this scenario is not working out very well. In fact, the Bauls of Bengal—a mystical sect originally found in northern India—practice a philosophy called *kaya sadhana* in which God is not only found on the earth, but in and through the human body. The goal of their spiritual practice is to saturate the human body and human experience with God so thoroughly that ordinary human expression becomes an expression of God Himself. Of course this must always be done with great humility so that we do not mistake the expression of our own egos for the process of God that moves through us, thus ending up with a useless and deluded messianic complex.

The point is to learn to find and enact God through the smallest details of life itself. If we are able to begin to live our lives in this way, it no longer matters what, if anything, we call God, nor does it matter whether we consider Him to be a failure or a success. When we have forfeited our notions of an imaginary God upon whom we can project all of our human weaknesses, we are left with the possibility for a kind of humanity that can be infused with a quality of ordinary magic that is likely to resemble something close to what God may really be. Whatever God is, surely It does not desire our flattery in the form of praise or criticism as much as It desires to be known and lived through human experience. This, at least, is the kind of God I am interested in.

THE FAILURE OF DEATH

SHORTLY BEFORE THIS BOOK was to go to the typesetter, I received a phone call: my mother was terribly ill. Two days later and having traveled to the other side of the country, I went with her to visit the oncologist and we learned that she was dying of cancer. Life becomes very, very real at these times. Many people know this from experience, and those who don't will come to experience it soon enough. Nobody escapes their own death or death of loved ones.

In the devastating blow of an immediate death sentence, 10,000 ideas of success and failure immediately dissipate into the ethers and only the most essential questions remain: "Has God (or Life) failed me?" And, "Have I failed my life?" The person who is dying asks this, as do all close family and friends. These are primal questions, existential ones, the very questions that lie between human misunderstanding and what we might call wisdom.

Just a week before this event I dreamt that I was to die within a year. My response was manifold. Initially, it was one of deep betrayal and profound failure. I had been gypped of the full life span. I had not been warned. I had not had the chance to become who I could have, to love the way I wanted to, to cease remaking the same mistakes. I had

not been given the necessary time to spiritually prepare for my own death. I went through layer after layer feeling betrayed by God, angry at myself, pissed off at the universe for not giving me better circumstances, and so on. And then I knew that I had not been betrayed. Nobody had promised me that I would live until eighty-five, that I would find ultimate spiritual fulfillment and surrender before the age of forty, that I would be given everything I asked for just because I had requested it. I had been given the gift of life— period. Nothing more and nothing less. The circumstance of my life warranted no special treatment. No extensions. I understood implicitly that there are ancient, karmic, and mysterious laws that rule my life and death—laws that I do not fully understand but that are passed down from the Universe itself. This is simply what I had been given. If I had "failed" until that point it was not God's fault but my own. Nobody had promised me another day to love as fully as I could when I had neglected to do so for all the days until that point. Nobody had said that I had plenty of time to write all the books that lie within me, to raise the child I so wished to. No. I had been given my life, and what I had or had not done with it was fully my responsibility.

So there my family was at the hospital, shocked upon receiving the news of my mother's impending death, and suddenly everybody turned into an atheist. My father felt his prayers had not been answered. My brother—a mature adult and father of three—cried, "If there was a God he wouldn't take Mom away like this." My mother herself, in shock and calmer than the rest of us, revealed that she had stopped believing in God forty years before when her moth-

er and brother had both died to painful illnesses at ages far younger then the ordinary life expectancy.

I listened to the commentary. I was as devastated as anyone in the family—overcome with grief—the only difference being that I could not accept the fact of her dying as a betrayal of God or a failure of anything that she or anybody else had done. Death is a part of life. Period. It is a difficult part of life—the singularly most challenging aspect of our existence we are faced with—but it is as real as our lives themselves. In reality, the failure would be to not die, for it is no more our right to live than our destiny to die. Both are inseparable and are what we are given.

Nobody in this world has ultimately betrayed us, because they can't. Relatively speaking, we have profoundly hurt and been hurt by others, but in the end it is only we who betray ourselves. Hafiz says that our wounds exist because our understanding hasn't deepened enough to forgive the dream of life. In other words, our imagined failure comes from our inability to perceive life as it is and to come into deep harmony with and acceptance of this circumstance.

When we learn that we are dying, we may feel that we have failed. We have not loved enough. We have treated others poorly. We have let our fears block us from fulfilling our dreams. We have regrets for things done and undone. Similarly, when we learn that somebody we love is dying or has died, we are often flooded with regret: we failed to forgive, we let unimportant grievances shadow the expression of our love, we were not understanding, we didn't help when we could have. We experience remorse over the most basic of human failings. In the act of true remorse, then, we

are profoundly connected to our humanity. We are alive. The conscious admission and experience of our failures suggests the possibility of a tremendous underlying success.

Regardless of what we have done or not done, the real question is: What are we going to do about it now? Maybe we did fail then, but are we going to continue to fail now? Or are we going to use any remaining time to finally love well, to cherish others, to express our affection, to ask for forgiveness, to forgive ourselves? And if we aren't given the luxury of the time to do these things with someone who is deceased, how can we be *now* with others in our lives so that we don't repeat those same mistakes? Perhaps death was given to us in order to prompt us to finally live well, to give us the opportunity for final success. A dear friend who was diagnosed with cancer began to live in a way few people ever do. She was already deeply engaged in her life until that point, but from the time of her diagnosis and into the final months and years of her life, those near her have been privileged to witness somebody who is looking death straight in the eye and radically embracing each minute of the gift of life she is offered for however long or short this precious opportunity remains.

So often it is only these "failures" that prompt us to do anything different in our lives. I began a life of serious spiritual practice after a near-fatal car accident when I was fifteen. Some people experience the richest time of their life as that period before their own death when they finally let go of the unimportant and begin to experience what is real and relevant. If thirty years of failed relationship with our father or daughter or brother have allowed us to finally share real and authentic love for even an hour, to find self-forgiveness and other-forgiveness, to be even a little bit more

loving to all those in our lives for the remainder of our lives, can we say with certainty that we have failed?

Many people who are faced with life-threatening illnesses believe that if they survive they have succeeded, and that if they die they have failed. Of course we *feel* that way, yet how can we really know that? It is not *we* who ultimately control our deaths, so how can *we* assume responsibility to know which outcome, if any, means success, and which signifies failure? Whether we believe in God, the Universe, or Evolution, something greater than ourselves guides the forces of our lives. The only thing we can control is how we relate to that which dictates our lives. Death is not a failure—it is what *is*—and thus any success or failure only comes from how we learn to relate to the circumstances. When people say, "So-and-so had a good death," it means that the individual was able to relinquish and surrender himself or herself to the process of death, not that they did not die.

If death was a failure, every great human being who has ever existed—including the prophets—has failed, because all have died. We seem to think that to die at thirty is a failure, but not at ninety-five. Or to die of a heart attack is a failure, but not of an earthquake. It is quite easy to see the highly subjective nature of such claims. A friend who is the disciple of a great Indian saint told me that he had once tried to commit suicide by drinking two full bottles of lethal poison—a quantity that would have been enough to kill twenty. The next day, when he visited the saint, who supposedly had no knowledge of his attempted suicide, the master greeted him by saying, "You really think you have control of your own life and death, don't you?"

If death is a failure, then we have all already failed, for we are all fellow travelers to the grave. But if death is the

ultimate reminder, the very incentive to *live*, the wake-up call to our souls, then perhaps it is not a failure at all but a profound opportunity. A final chance.

Grief is another one of the great gifts of death. Grief is something we dread. It rips us open, tears at our hearts, takes us deep into the abyss of loneliness and terror, into the interior worlds of self-doubt, regret, profound questioning, unimagined loss, and . . . love. Few things lead us to love as our grief does, because grief unmasks and dismantles all the layers of protection over our hearts. When we grieve we are open, and when we open we love. The seemingly intolerable seasons of grief are often interrupted with beautiful days of an increased capacity for love, patience, compassion, and a respect for our own and another's humanity that have to do neither with circumstance nor with ordinary happiness. When we are grieving we are vulnerable, we do not have the energy to resist the movements of life, we are willing to forgive. In our grieving for that which we love, we discover our own love and our own tenderness.

Grief is something we would never ask for, yet it provides us the opportunity for profound "success" in the face of death. It opens us to what is real, and when we are dwelling in the *Real*—whatever reality is—we simply cannot lose.

Lastly, all the great traditions tell us that in the ultimate scheme of things there is no death. People die but consciousness doesn't. The universe is made of pure con-

sciousness that manifests in endless forms, including that of the human. Human beings arise from consciousness and return to consciousness. The ordinary human identity—our egoic-identification—does die, but consciousness cannot and does not cease. When the saints speak of the discovery of deathlessness, they are addressing the capacity to identify with undying consciousness itself and not ordinary egoic identification. Their bodies will die as all bodies do, but they have discovered the nature of their essential identity and have therein been freed from the belief that death of the body means death of life. The intellectual knowledge of this deathlessness does not mean we will not suffer the very human experience of loss, sorrow, pain, attachment, but it does suggest that death may not be what we think it is, and certainly not a failure.

Since *who we are* essentially cannot die, perhaps there is no reality in the failure of death and instead only the failure of life: our lives. Are we living in such a way that we are able to appreciate the full opportunity of the inestimable gifts of life? I am not asking, "Are we doing it perfectly?" We aren't. We are failing. But are we embracing the opportunity of the lives we are given, as they are given to us, and using our imperfect bodies, minds and hearts in order to fulfill our individual expression of life? Or are we hiding behind fear and turning away from what is offered to us? Death will not fail us, it is only we who will fail ourselves, and whether we do so or not is literally our choice at every moment.

CHAPTER 14

INVESTING IN REALITY

THE POSSIBILITY OF WINNING through losing is discussed again and again throughout the book. If we are *lucky* enough to fail on the spiritual path—as even failure is not so easy—we lose our ideas of conventional happiness, our convictions about philosophy, our confidence in security, our attachment to our identity. We see that our plans fail, that meaning comes and goes, that our reality is comprised largely of subjective projections, that God isn't what we thought He was, that enlightenment doesn't mean much, and that the ego can never prevail. When we lose all of these things, what on earth do we win?!

If we can stay conscious through the losses, we stand to win a little slice of reality—a reality that may not be what we wanted it to be, that may not be of our choosing or our preference, that may conceivably be that which we most feared or dreaded, but a reality that is . . . well, *real*. Objectively real. Real in God's world. Real in the world of Truth. And that reality is worth all failures, and can and will unfold into untold possibilities.

It is not that reality is always such a wonderful thing. Okay, sometimes reality is just fine. Occasionally it even goes the way we want it to. We get the job we wanted, we

fall in love, our first child is born and we swoon in the ecstasy of the miracle of life. We share a moment of seemingly endless intimacy with our husband or wife, or we complete a project, or we touch a little bit of God from the scent in the air on a spring morning. Reality can be extraordinary, and most of us live for the moments in which it reveals its secret treasures.

Nevertheless, we all know that we will eventually lose the job we once wanted so badly, or that there will be conflict within the staff and we won't get the raise we wanted. We know that our relationship will meet difficulties, that our infant will demand of us more than we feel able to give, or that he or she will get sick and cause us terrible worry. We know that our experiences of satisfaction from our small successes will fade and only lead to craving for more satisfaction. In spite of what we would like to believe, our agony and our ecstasy are lovers, and they lie entwined in the bedchamber of our minds.

Reality can be wonderful, but sometimes it simply sucks. "Reality is hard and persistent and will knock you on your ass every time," Werner Erhard said. Reality is a taskmaster. It is the Divine Humbling Agent. It is what will literally bring all of us to our own deaths. It will sit on our shoulder watching us through all of our lies, our deceitfulness, our manipulation, our insecurity, and all of the games that we unconsciously and even understandably play in order to pretend things are different than they are. As we fall in and out of the sleep of unconsciousness and denial of life as it is, reality stays awake guarding the fort, waiting until eternity if it has to in order to see if we just might open even one eye to It.

In fact, reality is such a feared experience that most of humanity opts to avoid it most of the time and to instead live their entire lives within a field of subjective illusion. Spiritual seekers, as well as those who claim to have found, often speak about *maya*, or illusion, as if all phenomenal reality was false, and only some transcendent, invisible reality were real. However, any of us who have had our eyes opened even once, or have had our hearts touched even momentarily, can in no way safely say that our human lives are illusory. If somebody hits our finger with a hammer, it will hurt, and our pain will not be an illusion. Our lives are as real as the fact that we are breathing in this moment, and that when we die we will cease to.

Human beings do live in *maya*, but our *maya* is our illusory or false *relationship* to reality. It is not reality itself. And we choose to live in *maya* because the experience of reality can be hard to bear. Every time we turn away from being present to what life presents us with—a process that happens thousands and thousands of times every day—we are saying "no" to reality. We abandon ourselves again and again to the full impact of life because we are afraid of what will happen if we live without buffers. We prefer to live in the box we have created—whether it is a box of gold, or one of cardboard, or even one of cardboard covered with cheap gold paint—because it will generally give us exactly what we expect it to within a small margin. We will almost always choose the known before the unknown, because that is what human beings do in spite of the yearning of the heart for total abandon.

Reality presents, and represents, the singular possibility for us to experience aliveness—to experience ourselves wholly and without buffers in the face of the raw uncertainty and vulnerability that comprises our humanity.

Therefore we invest in reality—both as precious and as truly hideous as it will at times be—because it is our only hope to live as real human beings. We agree to fail and to lose in every possible domain of human experience solely for the possibility of experiencing what it means to be alive.

To invest in reality is to "say yes to life," in the words of Arnaud Desjardins. To say "yes" to life means that we are willing to take life on life's terms, and not on our own terms. We say yes to life either when we have failed and lost and fallen on our faces enough times to know that "we" can't do it right and that life won't work in the way the movies promised it would, or when we have glimpsed God long enough, or frequently enough, to trust Him to do a better job with us than we are able to.

There is an intelligence to the universe that few of us dare to allow ourselves to experience because we are so busy trying to control everything. The intelligence of the universe is evidenced in the human body that has the capacity to be almost entirely self-regulated and self-healing; this body that physically reproduces and replenishes its cells every seven years, that reproduces humanity itself, that allows for the possibility of sexual communion between human beings. The intelligence of the universe is tangibly and unquestionably present in all of nature—the nature that gives us everything we need to survive, thrive, and even destroy ourselves if we so choose; the nature that feeds us, that created an ecosystem of a perfection that no human being could conceive of. And the intelligence of the universe is even present in the human mind, in the seemingly backwards ego that can both bind and free us. The fact of the intelligence of the universe is obvious to everyone in some, if not many, moments, and yet

we ceaselessly doubt it, fail to see it, distrust it in favor of our own egoic intelligence.

Ram Dass said in a recent interview, "Your faith protects you." He didn't say that the universe protects you, or that some cosmic, guardian angel protects you. He said that *faith* protects you. And faith is not something that happens to us, but instead something that we enact. We act first, and life responds after. We give our faith to Life, or God, or Truth, and then quite conceivably that faith itself will take us in its arms. You see, if we have faith—and again this is not some cosmic, airy-fairy, mental structure we create in our minds but instead a wholehearted exposure of our guts to the bowels and heart of the universe—then we are already trusting that whatever is happening here and now is in fact the Will of the Universe, the very Will of God Itself. We are not turning away from what life brings us in the belief that we can do a better job than life can or in the belief that if we can figure out how to manipulate life to do what we want it to then our highest human possibility will be fulfilled. Instead, we are saying yes to *life as it is*, and our faith itself becomes our protection and our contentment.

When we accept reality as it is and on its own conditions, there arises the possibility for true compassion. Most people are capable of, and enact, acts of kindness. Fewer engage in moments of real compassion (though many can act the part). True compassion becomes part and parcel of our ongoing human experience when we have allowed ourselves to fail in life and come to accept reality as it is. Only then can we know ourselves to be truly equal with other human beings; only then can we cease to crave and cling to

only positive experiences, and cease to turn away from that which threatens our closed hearts. We can only be compassionate people—as opposed to doing a "random act of loving kindness" here and there—when we have been willing to bear the rawness and the often sharp edge of reality again and again and again.

Investing in reality has to do with the capacity to engage in right relationship to life. When we have "lost" our sense of meaning, our dreams, our fantasized hope of enlightenment and salvation, and any semblance of confidence in our ego's capacity for self-fulfillment, it can be quite tempting to fall into a kind of spiritual-existential depression, much in the way Nietzsche and others did. In spite of the loss of meaning, and even of imagined freedom itself, there remains a rightful relationship to every person, object and circumstance in life. Whereas this relationship to life remains devoid of meaning, purpose and even spiritual payoff, it is harmonious and complete in and of itself, and therefore holds an inherent satisfaction when lived properly. The satisfaction comes not from you or someone else feeling this way or that way, or because you are doing what is "right" or "good," but instead and only because you are engaged in a fully responsible relationship to life itself. Right relationship to life is a function of gratitude rather than scarcity. Instead of trying to get something or trying to succeed in any way, we understand that life itself—including its endless disappointments—is the gift, and that we can receive it in gratitude by honoring it for what it is.

Still another benefit of investing in reality is the development of the quality of clarity. When people begin the spiritual path they are dreaming of enlightenment and freedom from suffering. Oftentimes, even decades into the path, they are clinging to hopes of cosmic visions or spiritual

powers, while undermining the value of simple clarity. When one has walked the Way of Failure, and knows intimately the gargoyles and bandits that hang out in every internal corner of the mind, the possibility for seeing clearly becomes one of the most valued treasures. When we begin to see the value and gift of unadorned reality, and when we appreciate how hard it is to really see it and see *ourselves* in relationship to it, we begin to hold the possibility of clear-seeing far above imagined enlightenments and visions. Clarity is clear-seeing into reality, and reality is the only thing that is ever going to really satisfy us.

Reality *will not* be cheated, however. Most people (and I do not exempt myself from this in the least!) who grasp the Way of Failure and the possibility of winning through losing immediately start to negotiate. They unconsciously think to themselves, "I'm going to figure out how to make it really look like I have lost and failed and acknowledged my losses and have accepted reality as it is so that I can cash in on the goods." We actually do this. We try to mimic the Way of Failure, or fake acceptance of reality, believing (or wanting desperately to believe) that reality will actually be fooled by our antics and provide us with its genuine treasures in exchange for counterfeit payment. Once again, we think that either we are God, or that we can outsmart Him. Human beings are pretty funny creatures, and we should be able to laugh at ourselves for it, yet no matter what we do, reality will definitely not be fooled by us!

In the end, when we invest in reality we invest in ourselves. For some of us, thoughts of a life of compassion, truth, and selflessness, are really too overwhelming.

Perhaps an easier way to think of it is as a selfish, self-gaining proposition in which instead of seeking after financial or material gain, we are seeking to invest in the most valuable commodity that exists, but one that can't be bought with cash because it exists within us. We invest in our innate yet hidden capacities to be the kind of person we want to be and essentially are, beneath the endless layers of lovely and not so lovely *mierda* that we have dressed ourselves in. We could call it our Higher Self or our True Self or any other number of fancy titles, but we can also think of it as simply who we are when stripped from all falsity.

We fail and we fail in every phantasmal dream we imagined for ourselves through tirelessly trying to bite the carrot on a stick that in the end proves itself merely a mirage. And in our failings—over moments or lifetimes— we learn by experience what isn't real, what doesn't bring fulfillment, what will always disappoint us, and what our own limitations are. We win through losing every wish, fantasy, projection, ideal and morsel of meaning that we created and clung to in our desire for a different kind of joy than that which is rightfully ours. At last we find ourselves naked, but whole, and finally willing to stand in the fullness of our precious humanity.

CHAPTER 15

THE FAILURE OF FAILURE

FROM ONE PERSPECTIVE, failure is real, and we should not deceive ourselves about this fact. When we shame our child or hurt our loved ones, we have failed. When we murder others or even when we subtly manipulate them because of our own selfishness, we fail. As Joan Halifax communicated when she said, "I am a Zen failure," we fail a hundred or a hundred thousand times a day. We fail, and we should not excuse or dismiss ourselves from our failure by sloughing it off with some positive-thinking rationale about ultimate success. We can only fail if we fail to allow ourselves to fail. This may sound complex, but let us examine it more closely.

Failure is inevitable, but there is no guarantee of conscious failure. There is no guarantee that we as individuals can, or want to, or will be willing to turn toward our failure and make use of it in such a way that "it" will fail and in our allowance of this we will ultimately succeed. Failure promises to be the teacher, but even the greatest teacher cannot teach an unwilling student. Thus, although failure will always be willing to fail us into inevitable success, it cannot do so without our full and willing participation.

In ordinary terms, the failure of failure depends upon our increasing capacity and willingness to engage in the full domain of human frailty and limitation—only a few of which have been touched upon in this small book. We will fail no matter what we do, but we can *allow* ourselves to fail, and the very act of our allowing changes our failure from being something outside of us that we must separate ourselves from and thereby reject, to something that is included within our experience and can thus be integrated into the whole of our existence.

Failure fails when we make our failure *work* for us. "You made your bed, now lie in it," we are often reprimanded by the I-told-you-so inner and outer critics. Yet we imagine a bed of nails which we must bear through a sleepless night as a result of our misdeeds, failing to know that a bed of nails can be experienced as a mattress of rose petals if we lay upon it softly enough.

I once dreamt that I was being subtly and sweetly charmed and seduced by God Himself. At the moment of my "capture," a tube was flung into my nose and He began to madly suck all of the toxins, in the form of dark pus, out of my body, leaving the putrid liquid to drip all over the floor around us. When the time came to clean up the mess, as I wished to do since I was in the house of God, I was handed a broom and found that I was sweeping up the dried petals from a flower mala of roses that had been offered as a gift to God.

The point is that all failure that is offered up to a higher purpose—whether that be called God, Transformation, Love, whatever—becomes potential energy for the purification of our humanity. It is not that our failure must be offered up through some fancy cosmic ritual, or that each failure warrants an independent ceremony of intention

and renewal in order to become a useful transformative ingredient. Instead, the process can be as ordinary and uncomplicated as a simple and internal turning toward the fact of our failure and intending it to be of service to our own humanity.

Buddhists believe that birth in the human realm is the highest possible birth—even higher than that of the domain of the gods or the angels—because only human beings are provided the necessary combination of grace and suffering to motivate them to discover the wild source of their experience. The human realm is a realm of failure. Our failure is our clandestine passageway to a treasure chamber if we allow ourselves to enter it. Traveling with a spiritual master in Mexico, somebody asked him if he would like to visit some ruins and see the relics of a sacred door. "We are looking at the sacred door all the time," he said. "Why do we need to go to some ruins to look for that which we are unwilling to see all the time?" Our failure waits for us, begging to be mined for its riches.

There was a point in my life when I was about to do something that by all practical appearances looked totally stupid—kind of like standing at the edge of a cliff looking down at an ocean full of hundreds of hungry piranhas and deciding to jump in to see if just maybe they would play with me instead of eat me. At the time I said to my teacher, who was watching over me closely during this phase of my life, "When a hundred people have jumped into this same pool of piranhas and gotten eaten up, why would I do it as well?"

"Because *you* don't know that you'll get eaten," he said.

"But the statistics are certain," I insisted, "So why in hell would I consciously make this choice, knowing very well that I am asking for disaster, even if I don't fully 'know' that?"

"Because that is why you came here."

That is why I came here, and that is why we came here. We came to risk, to jump, to get chewed up into tiny pieces of piranha food, and then to get spit or shit out into the ocean of life. I was suddenly pushed into a full consideration of the fact that if I were to fully engage a real process of genuine transformation, I would now begin to make choices involving conscious heartbreak, conscious failure, the taking of conscious risks that in many cases involved a certain loss.

I began to realize that there exists a transformational process by which human beings *create* situations of suffering, loss, and heartbreak for a highly specific purpose, and that they create these situations not out of old neurotic patterns to perpetuate their own suffering, childhood abuse, or unfinished psychological cycles, but from an inner domain of wholeness. They look for failure, create failure, move into failure because even from their fullness they sense a rare possibility in still greater sacrifice, and still more after that. The certain "death" of failure promises them a possibility of life still unlived.

Again, *conscious suffering* is the process by which the human being makes a highly intentional choice to move into any number of domains of human suffering as a means and a vehicle toward the desired end of personal or spiritual transformation. Whereas such suffering is often viewed as outdated in the spiritual traditions—an aberrant expression of Judeo-Christian guilt, sin and penance that is not true of God nor serves the higher or lower good—and whereas it

has certainly been used in this way, perhaps this same suffering also holds an opportunity for something far beneath and beyond any notion of sin.

Let us consider that aside from the fact that God celebrates, procreates, and delights in His creation, that (in His own failure?) He also suffers for humanity. That although it was necessary to create a situation of immense perplexity, challenge and distress for human beings so that they might finally experience themselves, the inevitable sorrows of human beings are a source of unimaginable heartbreak to God Himself? And what if there existed a human possibility to move so closely in relationship with God—to become such a loyal servant, ally or lover—that one could be trusted and entreated to the precious task of sharing that suffering with God? What if, through our willingness to serve God or Truth itself, our once limited and bound human capacity could be expanded indefinitely—literally infinitely—in order to contain the suffering of humanity?

There is an extraordinary story about the late Indian saint Mother Krishnabai, successor to Papa Ramdas of Anandashram. Mother Krishnabai was known for her intense, though often ruthless, compassion, and for her nearly unparalleled capacity for mercy for humanity. [A beautiful account of her life can be found in the book, *Guru's Grace*. I found this book so extraordinary that one time when I spoke about it I offered to personally buy a copy of it for anyone who could not afford it themselves!] At one point in her life she begged God to allow her to absorb within her own body the full sorrow and suffering of all humanity. She quickly became extremely ill, and died nine months later. Skeptics and forlorn disciples argued that she mistakenly forgot to ask God also for the capacity to endure the suffering she wished to feel, but more true is that

she could not have been granted the ability to both feel *and* endure her suffering, and thus God mercifully granted her wish, knowing that she was fully aware of what she had asked for. Most of us are not destined to be as Mother Krishnabai, but all were born to fail.

What if failure was a wild disguise for success, and success for failure? What if God, or Truth (knowing how badly human beings wanted to succeed yet knowing how often they fail) hid true "success" within failure so that everybody—no matter who they are or what their circumstances—may have the chance to discover ultimate victory? What if failure is what we really have been looking for all along? After all, the Bodhisattva of Compassion sacrifices his own enlightenment until all human beings have been liberated, while knowing full well that this will never happen. His willful failure is his offering to all of humanity. When we allow ourselves to be heartbroken by the sorrow and joy of the human condition, just as it is given to us, we share in the Bodhisattva's commitment and thus open ourselves to the nectar and joy of true compassion. What if *that* is what failure was really about . . . ?

RECOMMENDED READINGS

Anderson, S. R. and Paul Ray. *The Cultural Creatives*. New York: Harmony Books, 2000.

Caplan, M. *Halfway Up the Mountain: the Error of Premature Claims to Enlightenment*. Prescott, Ariz.: Hohm Press, 1999.

—. *Untouched: the Need for Genuine Affection in an Impersonal World*. Prescott, Ariz.: Hohm Press, 1998.

—. *When Sons and Daughters Choose Alternative Lifestyles*. Prescott, Ariz.: Hohm Press, 1996.

Cohen, A. *An Unconditional Relationship to Life*. Lenox, Mass.: Moksha Foundation, 1995.

Desjardins, A. *Toward the Fullness of Life*. Prescott, Ariz.: Hohm Press, 1990.

Feuerstein, G. *Tantra: the Path of Ecstasy*. Boston: Shambhala, 1998.

John of the Cross. *Dark Night of the Soul*. Peers, E. Allison (ed.) New York: Doubleday, Image Books (a Division of Doubleday & Co., Inc.), 1959.

Jung, C. G. *Memories, Dreams, Reflections*. New York: Vintage Books, 1961.

Kapleau, P. *Awakening to Zen*. New York: Scribner, 1997.

Kornfield, J. *A Path with Heart: A Guide through the Perils and Promises of Spiritual Life*. New York: Bantam, 1993.

Ladinsky, D. (ed.) *The Gift: Poems by Hafiz the Great Sufi Master*. New York: Penguin/Arkana, 1999.

—. *I Heard God Laughing: Renderings of Hafiz*. Walnut Creek, CA: Sufism Reoriented, 1996.

Lewis, R. *The Perfection of Nothing: Reflections on Spiritual Practice*. Prescott, AZ: Hohm Press, 2000.

Lozowick, L. *The Alchemy of Transformation*. Prescott, Ariz.: Hohm Press, 1996.

Mitchell, S. (ed.). *The Selected Poetry of Rainer Maria Rilke*. New York: Vintage International, 1989.

Ring, K. *Lessons from the Light*. Portsmouth, N.H.: Moment Point Press, 1998.

Ryan, R. S. *The Woman Awake: Feminine Wisdom for Spiritual Life*. Prescott, Ariz.: Hohm Press, 1998.

Shaw, M. *Passionate Enlightenment*. Princeton, N.J.: Princeton University Press, 1994.

Svoboda, R. *Aghora*. Albuquerque, N. M.: Brotherhood of Life Inc., 1986.

—. *Aghora III: the Law of Karma*. Albuquerque, N. M.: Brotherhood of Life, 1997.

Trungpa, C. *Cutting through Spiritual Materialism*. Berkeley: Shambhala Publications, 1973.

—. *The Path is the Goal*. Boston: Shambhala, 1995.

Turner, C. *Layla and Majnun, by Nizami*. London: Blake Publishing Ltd., 1997.

Tweedie, I. *Daughter of Fire*. Inverness, Calif.: The Golden Sufi Center, 1986.

—. *Chasm of Fire*. Inverness, Calif.: The Golden Sufi Center, 1986.

Vaughan-Lee, L. *The Circle of Love*. Inverness, Calif.: The Golden Sufi Center, 1990.

Welwood, J. *Toward a Psychology of Awakening*. Boston: Shambhala, 2000.

INDEX

OTHER BOOKS BY MARIANA CAPLAN

HALFWAY UP THE MOUNTAIN
The Error of Premature Claims to Enlightenment
by Mariana Caplan
Foreword by Fleet Maull

Dozens of first-hand interviews with students, respected spiritual teachers and masters, together with broad research are synthesized here to assist readers in avoiding the pitfalls of the spiritual path. Topics include: mistaking mystical experience for enlightenment; ego inflation, power and corruption among spiritual leaders; the question of the need for a teacher; disillusionment on the path...and much more.

"Caplan's illuminating book...urges seekers to pay the price of traveling the hard road to true enlightenment." —*Publisher's Weekly*

Paper, 600 pages, $21.95 ISBN: 0-934252-91-2

• • •

WHEN SONS AND DAUGHTERS CHOOSE ALTERNATIVE LIFESTYLES
by Mariana Caplan

A guidebook for families in building workable relationships based on trust and mutual respect, despite the fears and concerns brought on by differences in lifestyle. Practical advice on what to do when sons and daughters (brothers, sisters, grandchildren...) join communes, go to gurus, follow rock bands around the country, marry outside their race or within their own gender, or embrace a religious belief that is alien to yours.

"Recommended for all public libraries."—*Library Journal.*

"Entering an arena too often marked by bitter and wounding conflict between worried parents and their adult children who are living in non-traditional communities or relationships, Mariana Caplan has produced a wise and thoughtful guide to possible reconciliation and healing...An excellent book."
—Alan F. Leveton, M.D.; Association of Family Therapists, past president

Paper, 264 pages, $14.95 ISBN: 0-934252-69-6

TO ORDER PLEASE SEE ACCOMPANYING ORDER FORM
OR CALL 1-800-381-2700 TO PLACE YOUR ORDER NOW.
VISIT OUR WEBSITE TO PLACE YOUR ORDER — www.hohmpress.com

OTHER BOOKS BY MARIANA CAPLAN

UNTOUCHED
The Need for Genuine Affection in an Impersonal World
by Mariana Caplan Foreword by Ashley Montagu

The vastly impersonal nature of contemporary culture, supported by massive child abuse and neglect, and reinforced by growing techno-fascination are robbing us of our humanity. The author takes issue with the trends of the day that are mostly overlooked as being "progressive" or harmless, showing how these trends are actually undermining genuine affection and love. This uncompromising and inspiring work offers positive solutions for countering the effects of the growing depersonalization of our times.

"To all of us with bodies, in an increasingly disembodied world, this book comes as a passionate reminder that: Touch is essential to health and happiness."—Joanna Macy, author of *World as Lover, World as Self*

Paper, 384 pages, $19.95 ISBN: 0-934252-80-7

• • •

WHEN HOLIDAYS ARE HELL....!
A Guide to Surviving Family Gatherings
by Mariana Caplan

An upbeat guide for meeting the expectations and challenges of family gatherings. From unresolved conflicts to reconciiling differences in lifestyle, Caplan offers keys to unlocking dozens of potentially unpleasant situations.

"This book will help readers maximize the pleasures and minimize the hassle of family holiday celebrations in these nerve-wracking times. A good job, and quite timely."—Chuck Langham, Executive Director, S.C.R.O.O.G.E. International (The Society to Curtail Ridiculous, Outrageous and Ostentatious Gift Exchanges)

Paper, 144 pages, $7.95 ISBN: 0-934252-77-7

TO ORDER PLEASE SEE ACCOMPANYING ORDER FORM
OR CALL 1-800-381-2700 TO PLACE YOUR ORDER NOW.
VISIT OUR WEBSITE TO PLACE YOUR ORDER — www.hohmpress.com

ADDITIONAL TITLES FROM HOHM PRESS

THE JUMP INTO LIFE: *Moving Beyond Fear*
by Arnaud Desjardins
Foreword by Richard Moss, M.D.

"Say Yes to life," the author continually invites in this welcome guidebook to the spiritual path. For anyone who has ever felt oppressed by the life-negative seriousness of religion, this book is a timely antidote. In language that translates the complex to the obvious, Desjardins applies his simple teaching of happiness and gratitude to a broad range of weighty topics, including sexuality and intimate relationships, structuring an inner life, the relief of suffering, and overcoming fear.

Paper, 216 pages, $12.95 ISBN: 0-934252-42-4

• • •

THE SHADOW ON THE PATH
Clearing the Psychological Blocks to Spiritual Development
by VJ Fedorschak Foreword by Robert K. Hall, M.D.

Tracing the development of the human psychological shadow from Freud to the present, this readable analysis presents five contemporary approaches to spiritual psychotherapy for those who find themselves needing help on the spiritual path. Offers insight into the phenomenon of denial and projection.

Topics include: the shadow in the work of notable therapists; the principles of inner spiritual development in the major world religions; examples of the disowned shadow in contemporary religious movements; and case studies of clients in spiritual groups who have worked with their shadow issues.

Paper, 324 pages, $17.95 ISBN: 0-934252-81-5

**TO ORDER PLEASE SEE ACCOMPANYING ORDER FORM
OR CALL 1-800-381-2700 TO PLACE YOUR ORDER NOW.
VISIT OUR WEBSITE TO PLACE YOUR ORDER — www.hohmpress.com**

ADDITIONAL TITLES FROM HOHM PRESS

THE ALCHEMY OF LOVE AND SEX
by Lee Lozowick Foreword by Georg Feuerstein, Ph.D.

Reveals 70 "secrets" about love, sex and relationships. Lozowick recognizes the immense conflict and confusion surrounding love, sex, and tantric spiritual practice. Advocating neither asceticism nor hedonism, he presents a middle path—one grounded in the appreciation of simple human relatedness. Topics include:* what men want from women in sex, and what women want from men * the development of a passionate love affair with life * how to balance the essential masculine and essential feminine * the dangers and possibilities of sexual Tantra * the reality of a genuine, sacred marriage. . .and much more.

" ... attacks Western sexuality with a vengeance." —*Library Journal.*

Paper, 300 pages, $16.95 ISBN: 0-934252-58-0

• • •

WRITING YOUR WAY THROUGH CANCER
by Chia Martin

This book applies tried and true methods of journaling and other forms of writing to the particular challenges faced by the cancer patient. Research confirms that people who write about their upsetting experiences show improvement in their immune system functioning. Thousands of cancer patients today could profit from the journal writing techniques and inspiration offered in this practical, comforting, yet non-sentimental, guidebook. Its wisdom is useful to anyone who faces a personal health crisis; or anyone who wishes to confront their grief, loss or a difficult present reality with less panic, fear and confusion.

"Chia Martin's story is a vivid reminder of the importance of psychological and spiritual issues in healthcare."—Larry Dossey, M.D., author, *Reinventing Medicine* and *Healing Words*

Paper, 192 pages, $14.95 ISBN: 1-890772-003

**TO ORDER PLEASE SEE ACCOMPANYING ORDER FORM
OR CALL 1-800-381-2700 TO PLACE YOUR ORDER NOW.
VISIT OUR WEBSITE TO PLACE YOUR ORDER — www.hohmpress.com**

RETAIL ORDER FORM FOR HOHM PRESS BOOKS

Name_____ Phone (_____)_____

Street Address or P.O. Box _____

City _____State _____ Zip Code _____

	QTY	TITLE	ITEM PRICE	TOTAL PRICE	
	1	**THE ALCHEMY OF LOVE AND SEX**	$16.95		
	2	**HALFWAY UP THE MOUNTAIN**	$21.95		
	3	**THE JUMP INTO LIFE**	$12.95		
	4	**THE SHADOW ON THE PATH**	$17.95		
	5	**UNTOUCHED**	$19.95		
	6	**THE WAY OF FAILURE**	$14.95		
	7	**WHEN HOLIDAYS ARE HELL**	$7.95		
	8	**WHEN SONS AND DAUGHTERS . . .**	$14.95		
	9	**WRITING YOUR WAY THROUGH CANCER**	$14.95		

SURFACE SHIPPING CHARGES

1st book ..$5.00

Each additional item$1.00

SUBTOTAL: ____

SHIPPING: (see below) ____

TOTAL: ____

SHIP MY ORDER

☐ Surface U.S. Mail—Priority ☐ UPS (Mail + $2.00)

☐ 2nd-Day Air (Mail + $5.00) ☐ Next-Day Air (Mail + $15.00)

METHOD OF PAYMENT:

☐ Check or M.O. Payable to Hohm Press, P.O. Box 2501, Prescott, AZ 86302

☐ Call 1-800-381-2700 to place your credit card order

☐ Or call 1-520-717-1779 to fax your credit card order

☐ Information for Visa/MasterCard/American Express order only:

Card #_____–_____–_____–_____ Expiration Date _____

Visit our Website to view our complete catalog: www.hohmpress.com

ORDER NOW! Call 1-800-381-2700 or fax your order to 1-520-717-1779.

(Remember to include your credit card information.)

CONTACT INFORMATION

By request, Mariana Caplan leads seminars both in the U.S. and in Europe based upon her various books. She also works as a private counselor and as a consultant to aspiring writers. Further information can be found at: www.realspirituality.com, or by writing to her c/o: Hohm Press, Box 2501, Prescott, AZ, 86302.